Figure
Drawing Methods for Artists

Quarto is the authority on a wide range of topics.

Quarto educates, entertains and enriches the lives of our readers—enthusiasts and lovers of hands-on living.

www.QuartoKnows.com

Translation © 2017 Quarto Publishing Group USA Inc.
The original German edition was published as *Figur: Menschen zeichnen.*

© 2016 by Haupt Berne, Switzerland
www.haupt.ch

First Published in the United States of America in 2017 by Rockport Publishers, an imprint of The Quarto Group, 100 Cummings Center, Suite 265-D, Beverly, MA 01915, USA.
T (978) 282-9590 F (978) 283-2742 QuartoKnows.com

Rockport Publishers titles are also available at discount for retail, wholesale, promotional, and bulk purchase. For details, contact the Special Sales Manager by email at specialsales@quarto.com or by mail at The Quarto Group, Attn: Special Sales Manager, 401 Second Avenue North, Suite 310, Minneapolis, MN 55401, USA.

10 9 8 7 6 5 4 3 2 1

ISBN: 978-1-63159-306-2

Library of Congress Cataloging-in-Publication Data available.

Cover, design, and artwork: Peter Boerboom and Tim Proetel

Printed in China

MIX
Paper from
responsible sources
FSC
www.fsc.org FSC® C016973

Peter Boerboom and Tim Proetel

Figure
Drawing Methods for Artists
Over 130 Methods for Sketching, Drawing, and Artistic Discovery

Contents

From Line to Figure

From Line to Figure

To create a picture of the human figure is a never-ending theme in art. Whether as perfect half-gods and beauty queens or realistic, touchable individuals, or whether as imposing rulers or tormented souls, images outlast us and tell of our time, our misery, and our dreams.

We're surrounded by photographic images. Quickly created and often shared, they are ever present in today's picture-cosmos but a drawn human figure is different. It is unique. The creation is more than just pushing a button; it is an intense moment of observation, followed by decisions, which are made with every line. How do I interpret what I see and show what I mean?

To sketch a figure means to capture it, fix it in our mind just like a fleeting thought, and contain it on a piece of paper. This skill can be developed through close observation. Experimentation is another approach to constructing a figure, which can be accomplished without a subject. A spot turns into an idea, a line leads to a concept, and from that a figure is developed. Try it out! Look! And try again! Figures don't have to be anatomically correct if the outlines are imaginative and the lines and expression are lively.

The focus of this book is the enjoyment of drawing and the question of how to draw people successfully with both simple and more complex methods. We show you how to comprehend the human figure and build up a repertoire for your own approach while doing so. We invite you to experiment and venture into the big theme of figure, body, and human.

1. Shrink

The fear of drawing people incorrectly can be inhibiting, but with simple tools and basic knowledge, we can commit to paper expressive, funny, refreshing, and surprising figures. Quickly drawing miniature figures relieves the pressure to achieve something grand. Not every detail has to be right; ideas are noted and jotted down on paper. You will gradually develop a sense for proportions and an eye for posture. Without the constraint of fear, you may end up creating a line of figures that tell their own narrative.

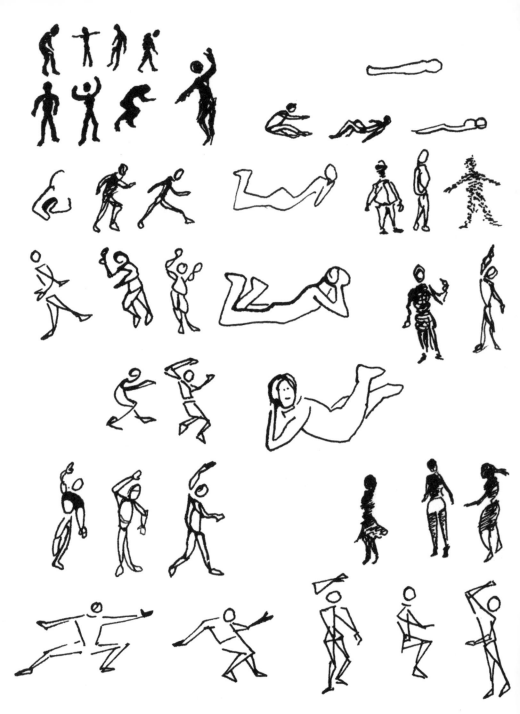

Use different approaches to collect ideas.

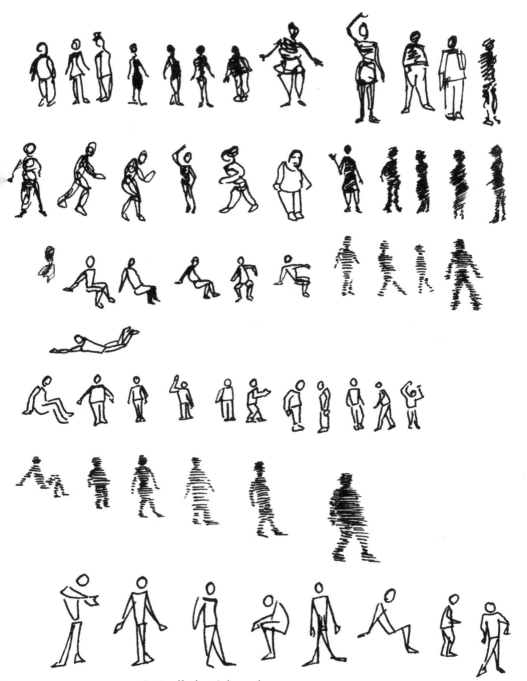

Let all the ideas happen on paper.
The ones that are fun can then be explored further.

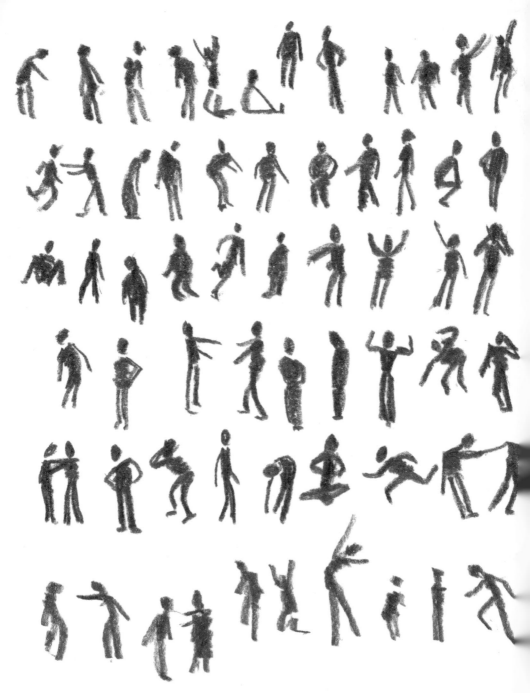

Think simple; quickly move from figure to figure and find a
rhythm. The figures next to each other turn into a scene.

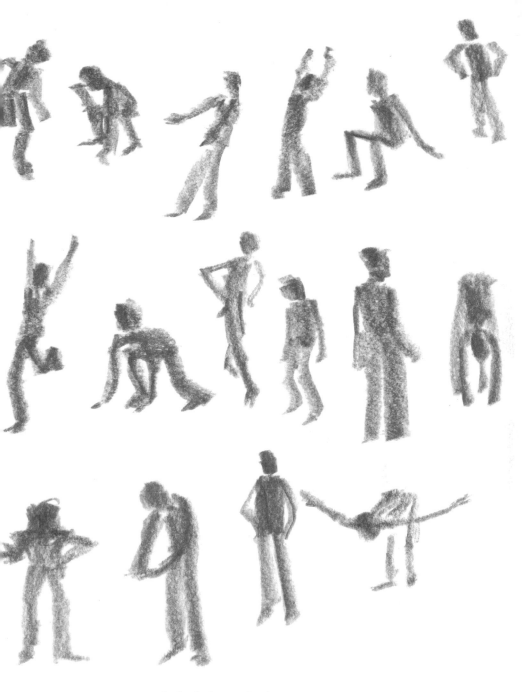

Label theatrical postures
or create dialogues that could inspire more ideas.

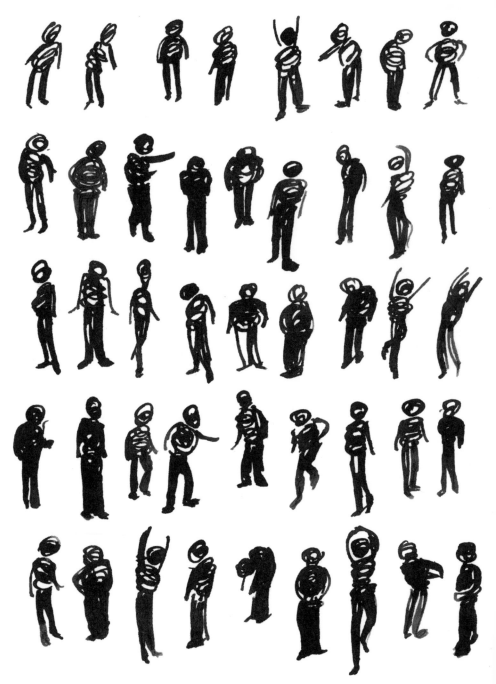

Use circular motions to create heads and
torsos for your figures.

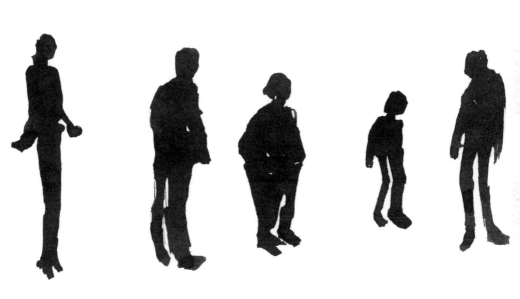

Create distinctive silhouettes by considering
body build, posture, hairstyle, and age.

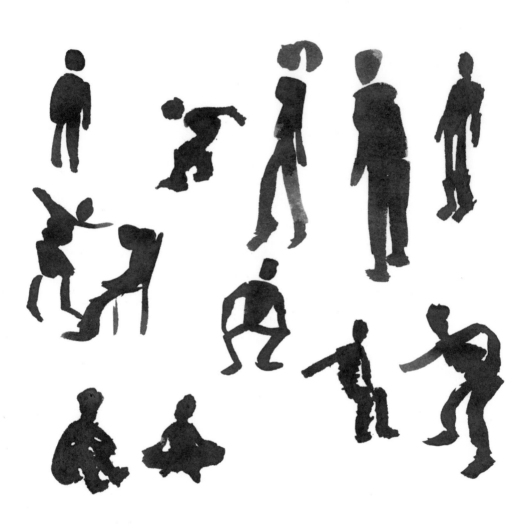

Shifting the position of the feet adds spatial orientation.

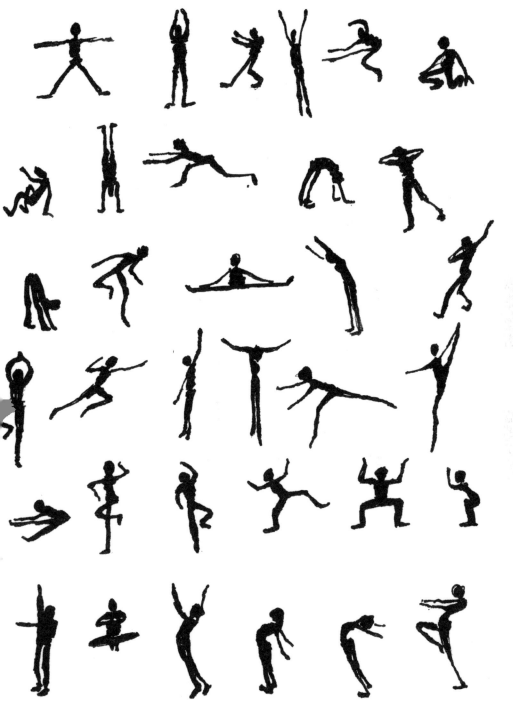

Stretch the body from the hands, feet, and head.

Explore different poses while drawing with a brush.

Add more detailed hands and feet.

2. Outline

People, like other objects, don't have physical outlines. Indeed, the figure distinguishes itself from its environment but because of each movement, turn, or change of perspective, the form varies. The contour only emerges once a line captures the body. This is an invention of drawing, maybe even the most fundamental. The outline makes it possible to create simple, concise figures from three-dimensional entities. That's how the line separates the figure from the background; outside of the contour lives the rest of the world.

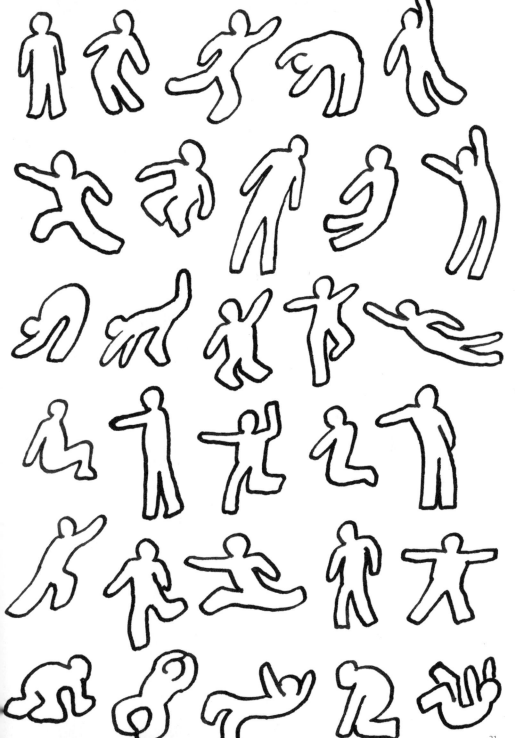

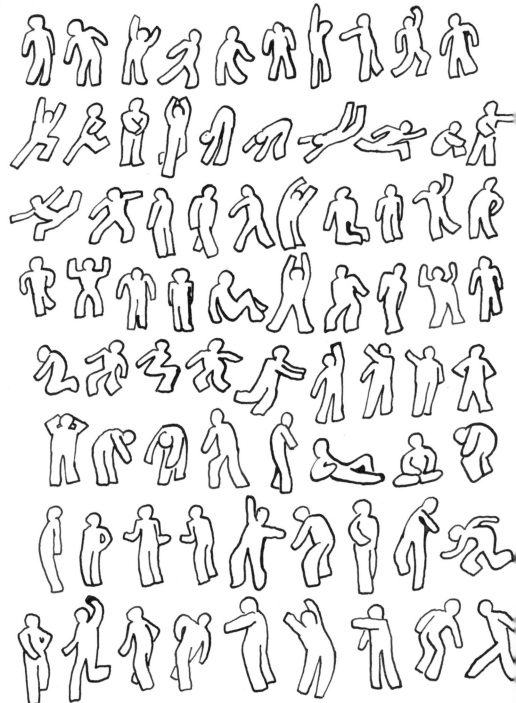

Legs and arms give the figure movement and life.

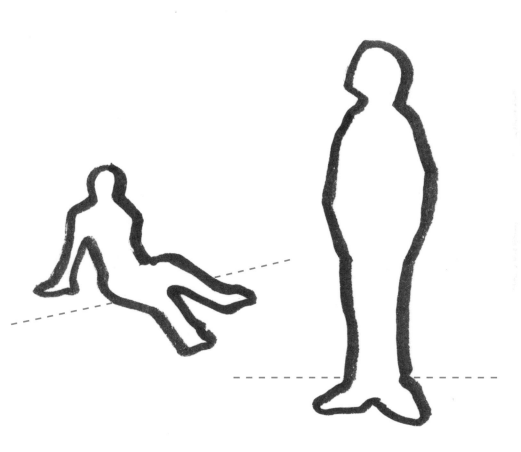

The suggestion of hands and feet stabilizes these figures
and highlights their positions in the imagined space.

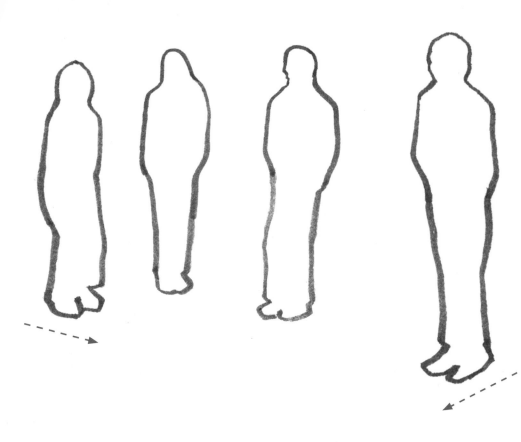

Is this the front or the back of the figure?
The position of the feet provides clarity.

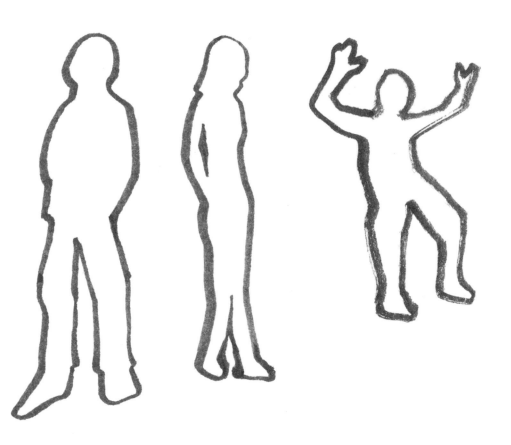

A slowly drawn line ensures concentration on particular details.

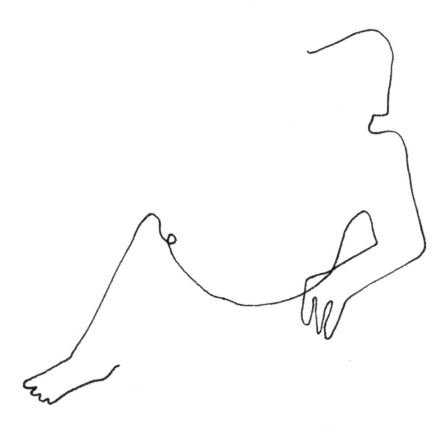

Draw a continuing line and bend it like a piece of wire.

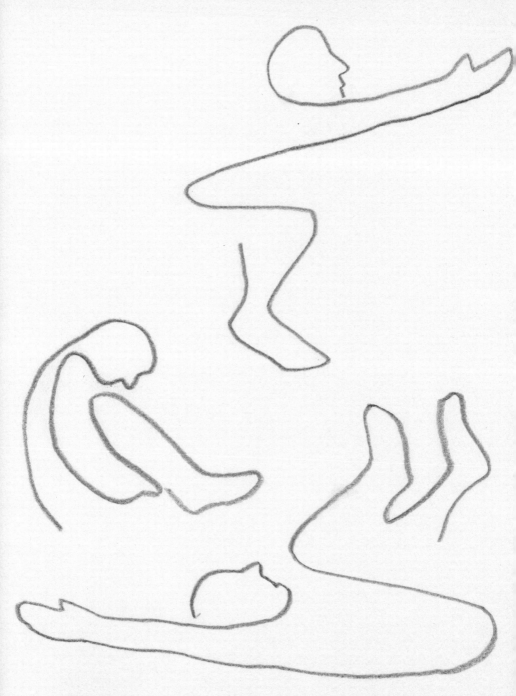

Ambiguous lines can confine areas or open them up.

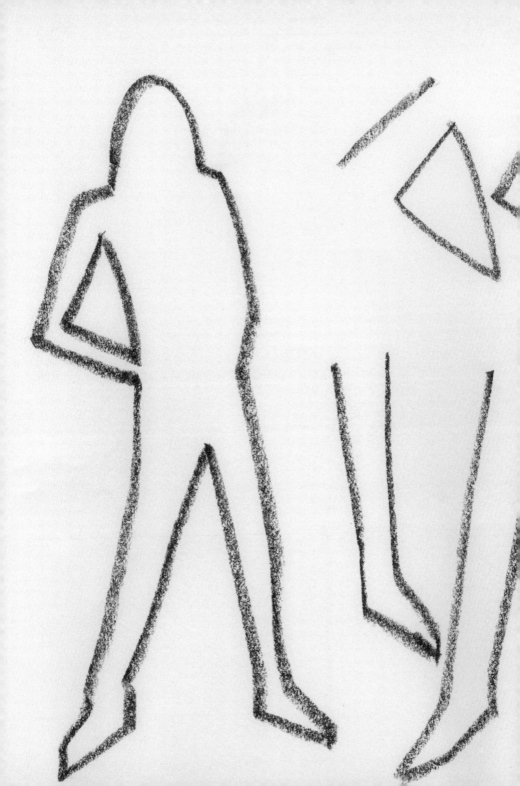

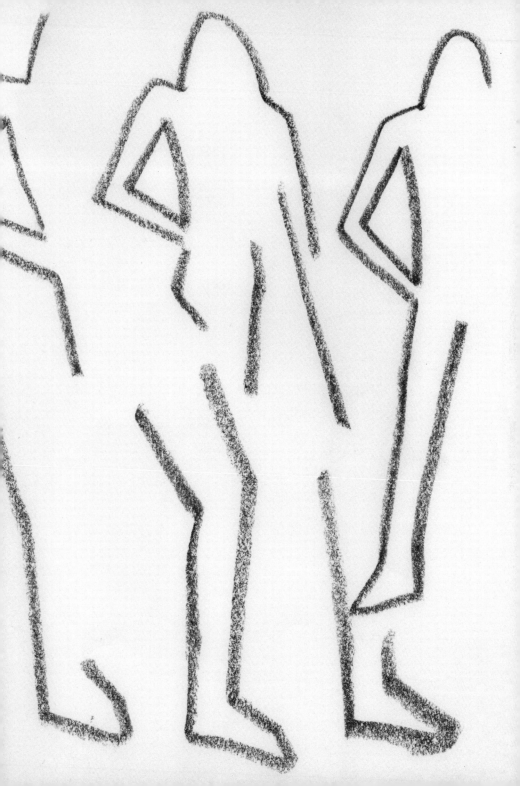

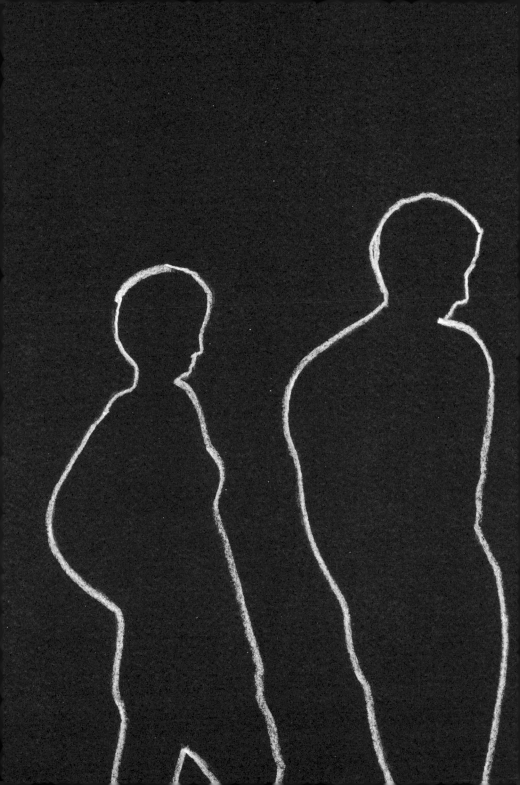

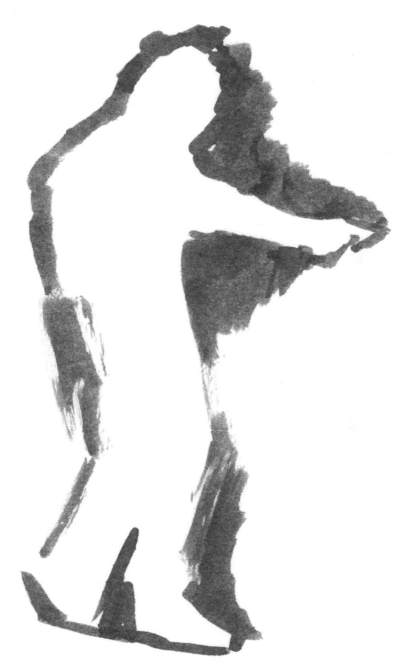

This figure is drawn from the outside.

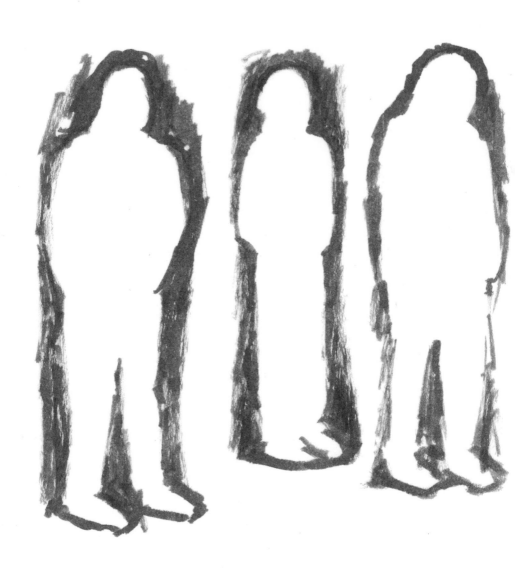

These figures look like they've been
carved out of pieces of wood.

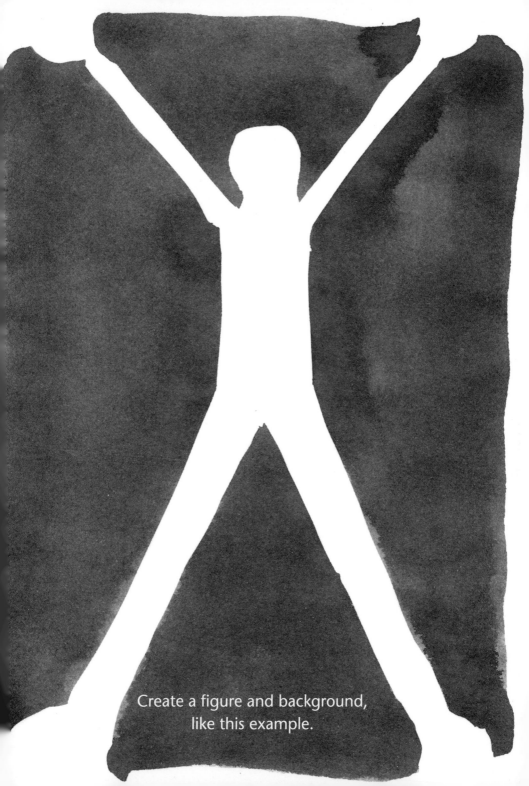
Create a figure and background,
like this example.

3. Interior Contour

The outline is continued toward the inside and follows the visible overlaps. This way, the figure doesn't only distinguish itself from the background as a closed form, but becomes a conceivable form by adding contours within. Looking at a side view of the figure, the arms and legs appear behind rather than next to each other, and they overlap with other body parts. The linear contours of a figure turn into a lively interplay of hints and recesses of light and shadow.

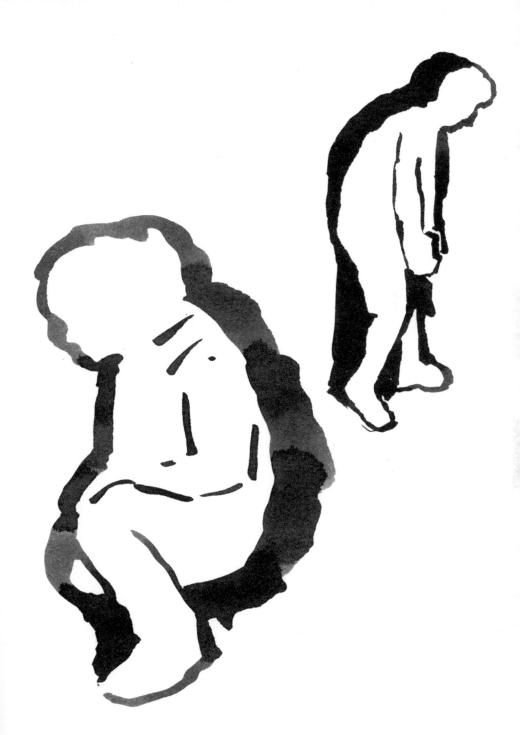

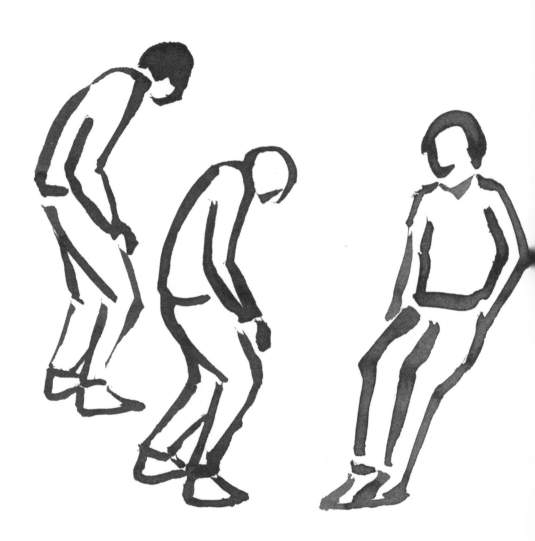

Contours within the figure become necessary when exterior
lines overlap and make it difficult to discern the different parts
of the body from one another.

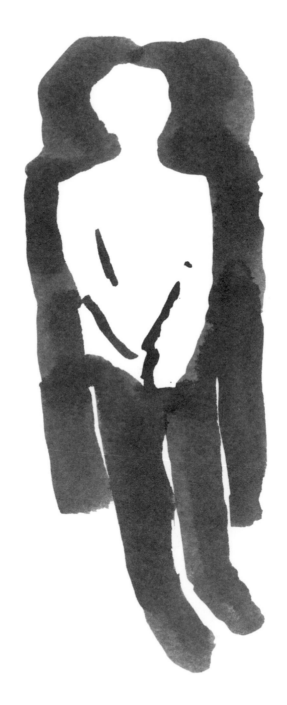

Create a figure by drawing light for dark and dark for light.

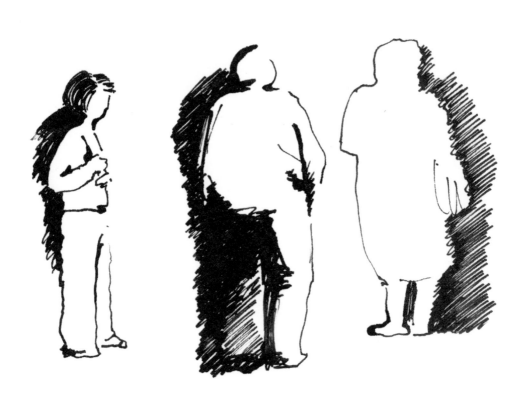

On one side, the simple line is enough; on the other side,
a two-dimensional shadow borders the figure.

Open shadows connect the figures
with their environment.

The optical equilibrium is balanced
between light and dark.

Differentiate contours within the figures.

Combine the silhouettes of body fragments and
arrange them into tight groups of people.

4. Join Together

Consider the limbs on a figure as reduced singular shapes that are combined into many variations. In random assembly, such as on a mannequin or when performing a jumping-jack, the segments overlap where joints and hinges would be. Hints and open space between parts are enough to indicate the posture or movement of a human figure. Extremes can be explored and the order of these parts doesn't always have to make perfect sense. Understanding how the different parts of the human figure work together is about testing possibilities and impossibilities.

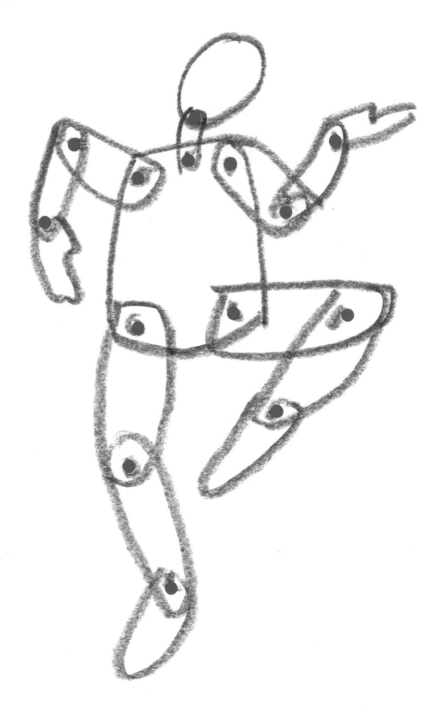

Note where all the joints are in this jumping figure.

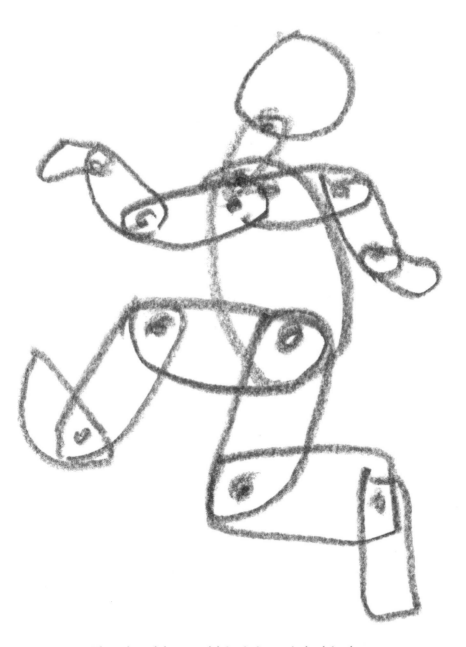

The shoulder and hip joints sit behind
each other in a side view.

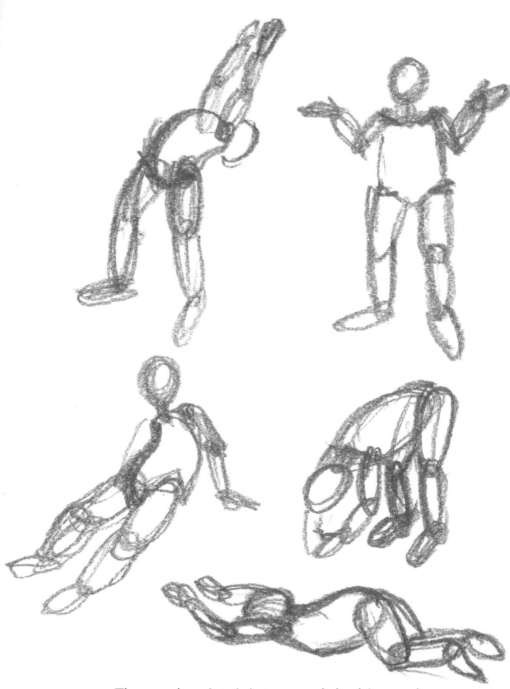

The overlapping joints propel the hips and
knees forward so they appear closer to the viewer.

Try segmenting: Separating the arms into sections gives them the appearance of movement.

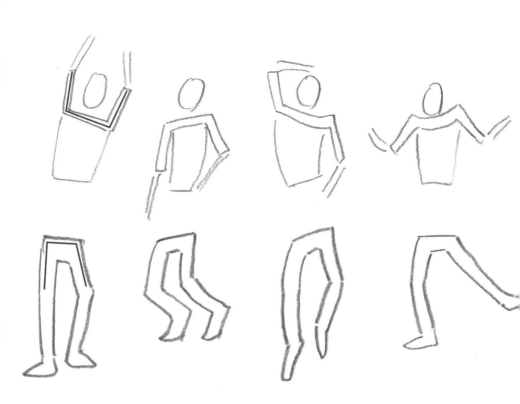

Note the arcs in the shoulders and upper arms
and in the hips and legs.

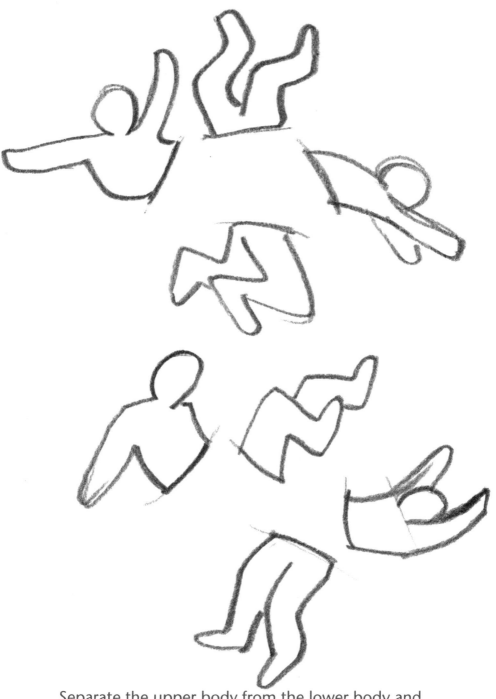

Separate the upper body from the lower body and
make each section appear to move.

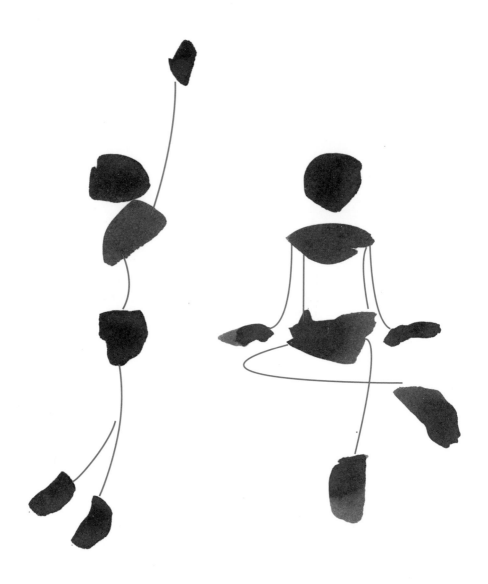

Think about spacing and arrangement
when placing shapes near one another.

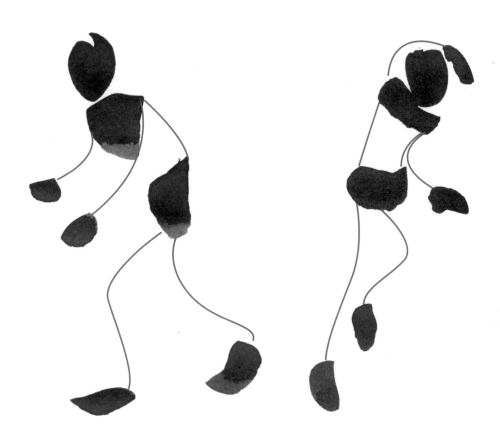

Start with shapes for the head, shoulders, and pelvis
and then add the hands and feet.

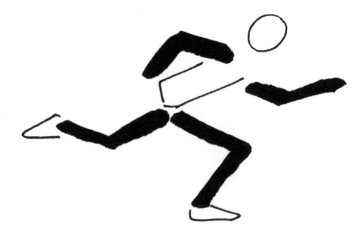

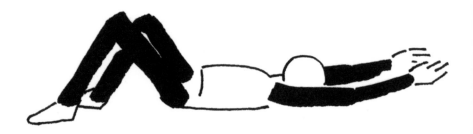

First draw the arms and legs using a wide brush,
adding a bend at the joints.

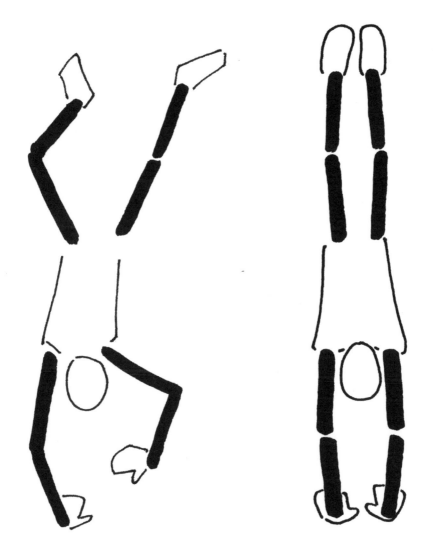

Next, add the upper body and head.
In which direction should the hands and
feet point for a handstand?

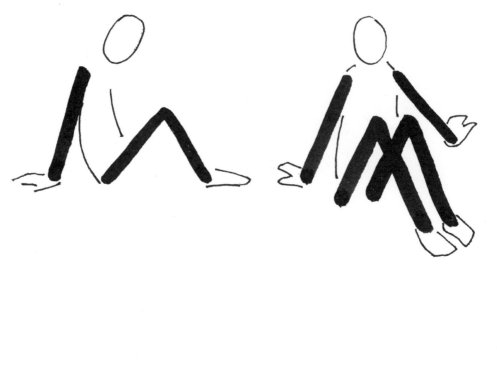

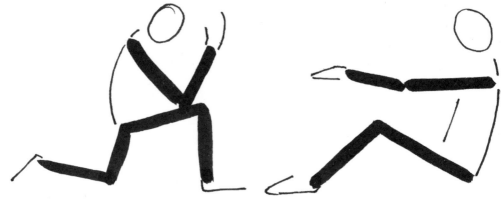

Each change creates a new posture.
Add the thin lines after the arms and legs.

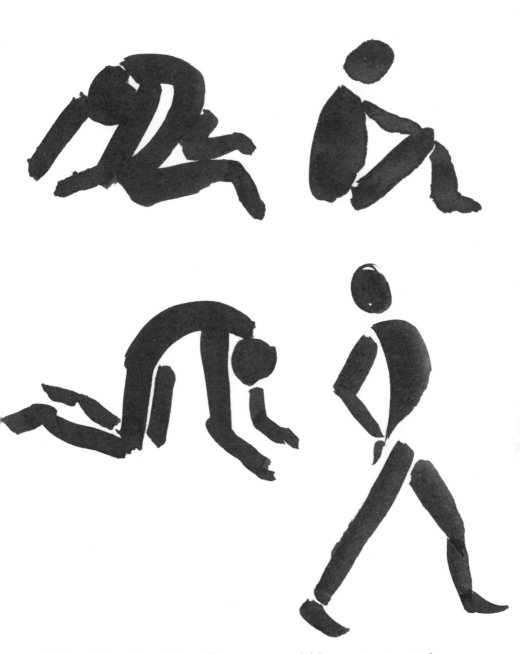

Paint with a brush just like you would lay out cutout shapes
on a piece of paper and assemble them.

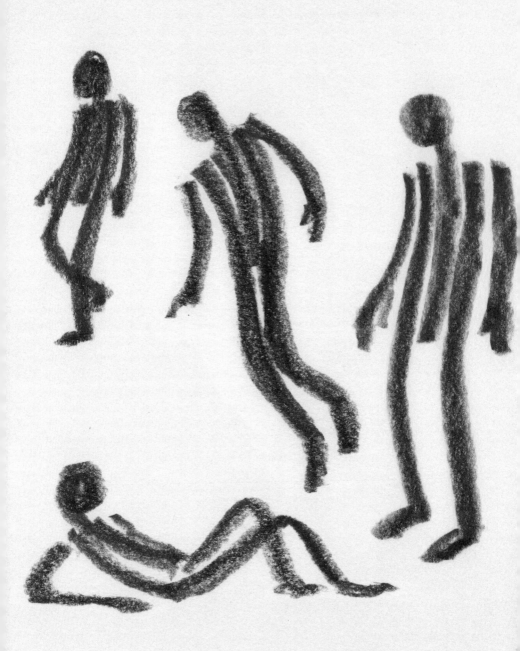

Five strokes make up a figure.

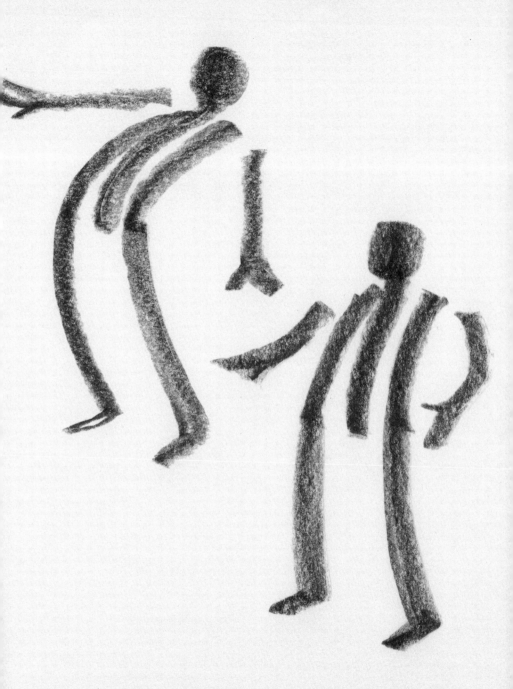

The long lines from the shoulder to the heel include the hips.

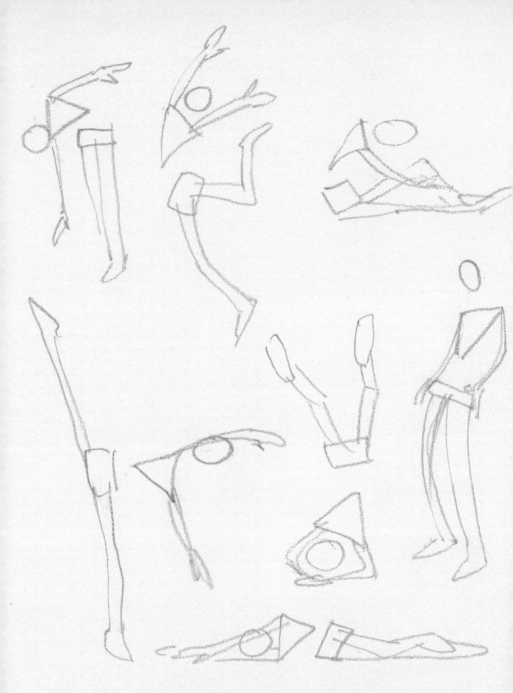

Movement comes from loose
configurations of the basic shapes.

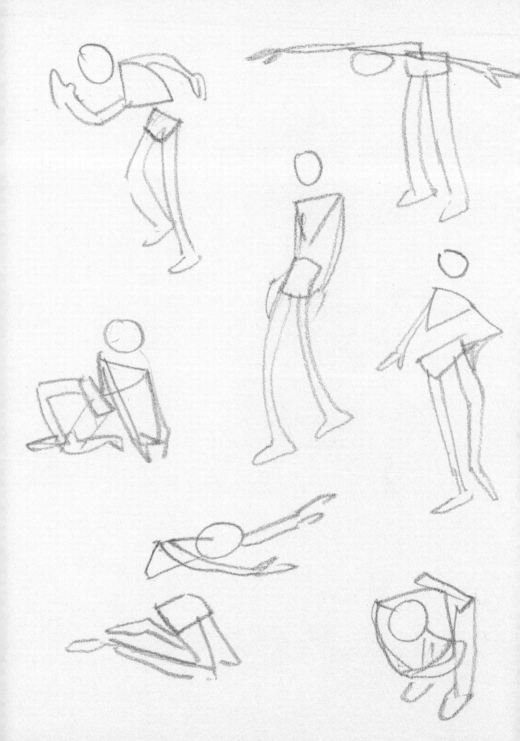

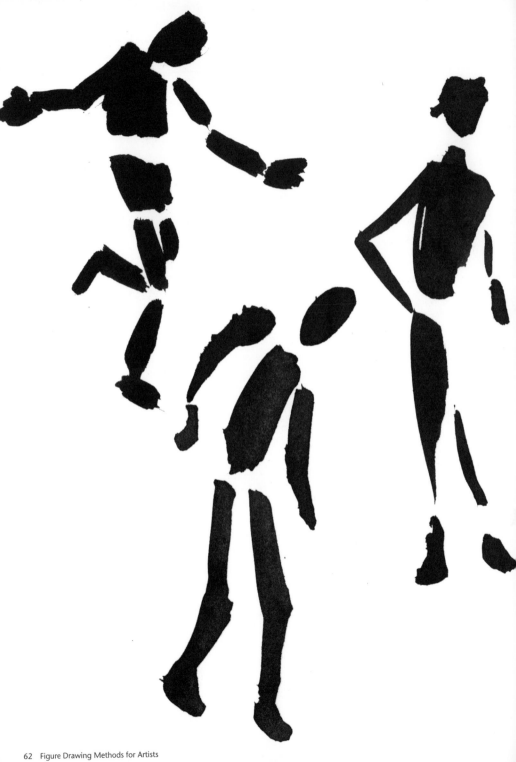

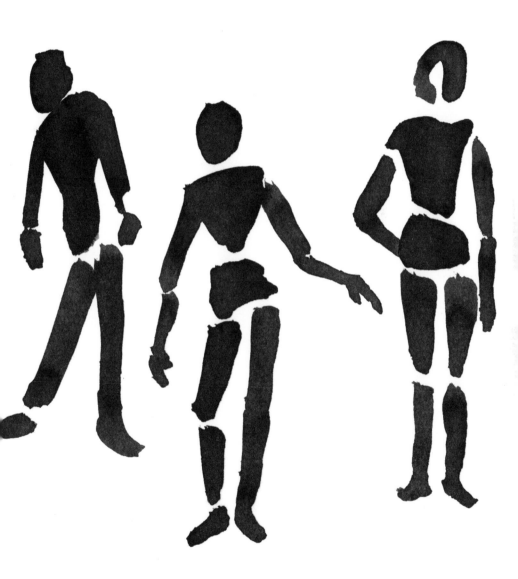

You can either split up the different parts of the figure or keep them together during the drawing process.

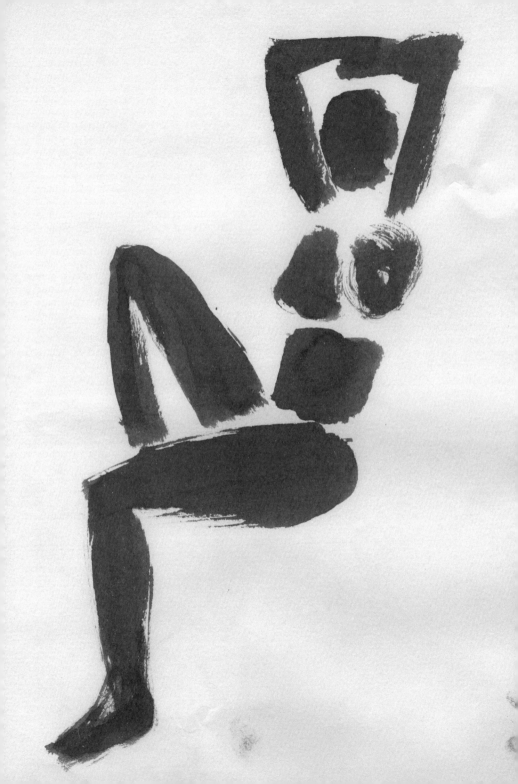

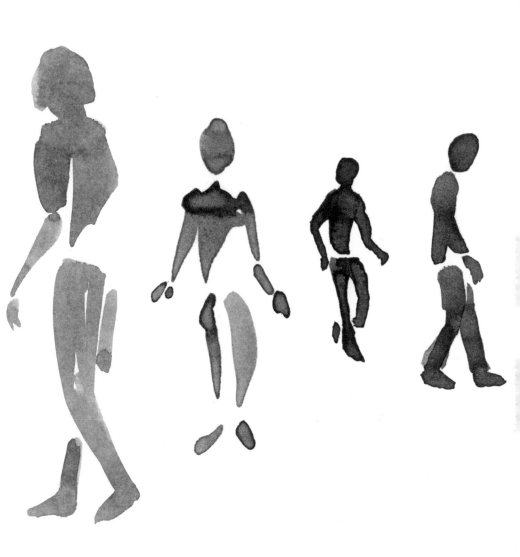

Differentiate the joints and leave empty spaces in between.

5. Structure

Creating the framework is the beginning to developing a figure from the inside out. While drawing, the framework is imagined, with the design stemming from where the emphasis must be to give the figure stability. A flexible vertical line, derived from the spine, as well as moveable horizontals (shoulders and hip girdle), are the most important axes on which the whole figure is oriented. Finally, the body is laid around the structure like a shell—it surrounds it.

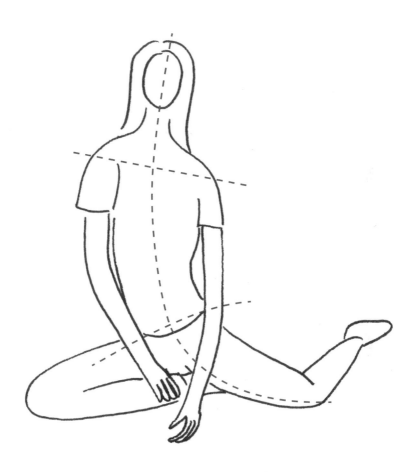

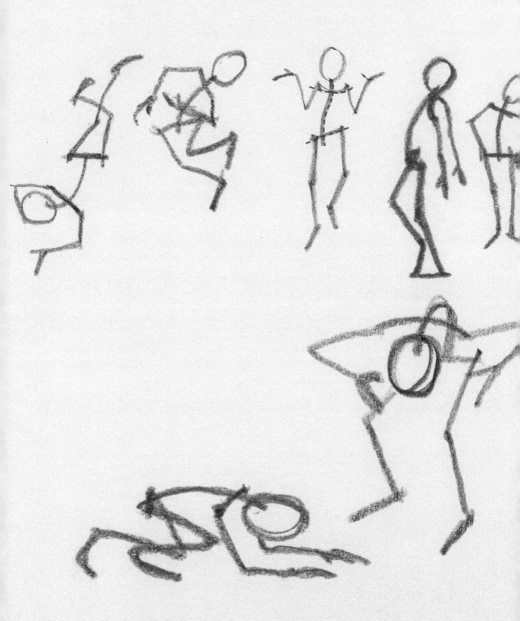

Create an *I* for the shoulders, spine, and hips.

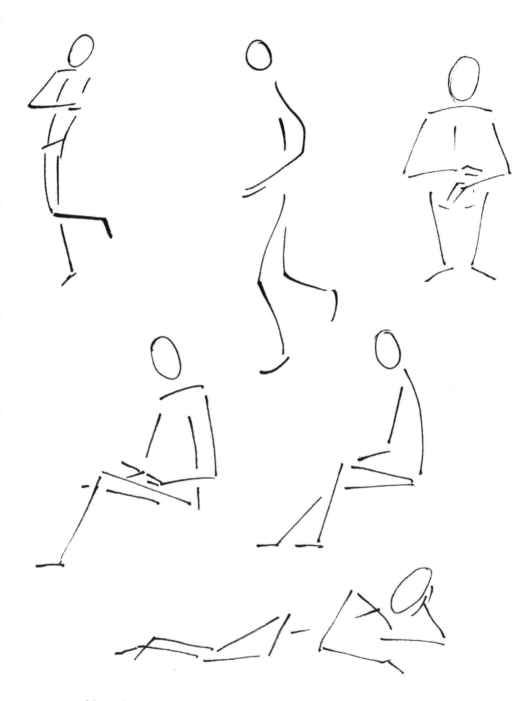

Use simple lines to create a skeleton structure.

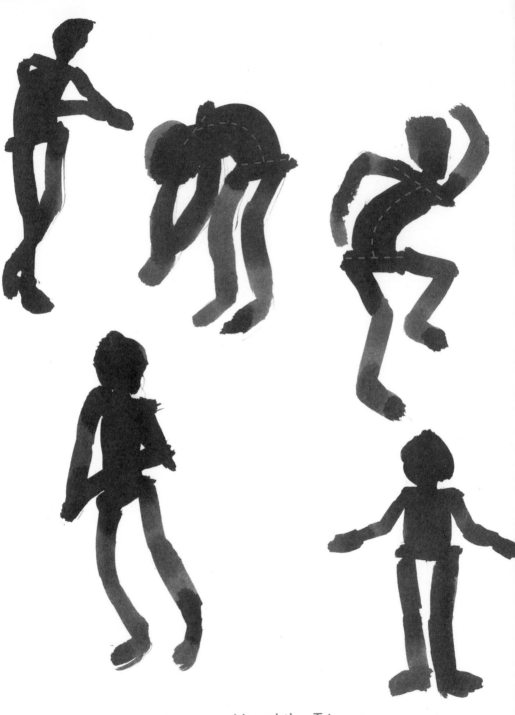

Curve and bend the I torso.

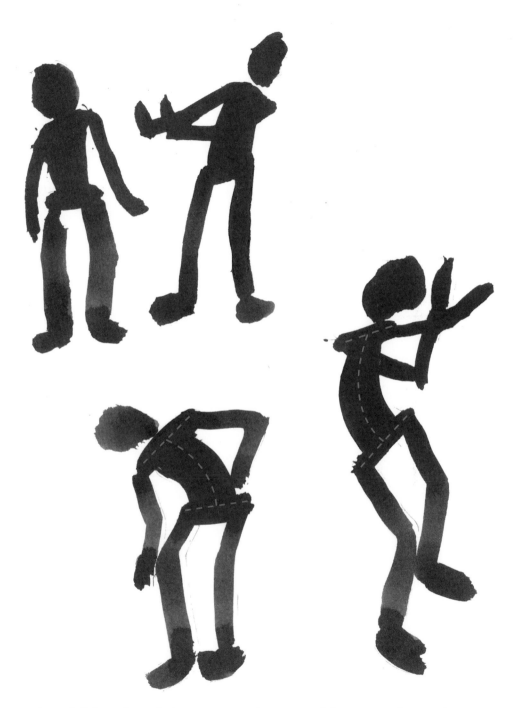

In addition, bend the axes so that one side curves inward.

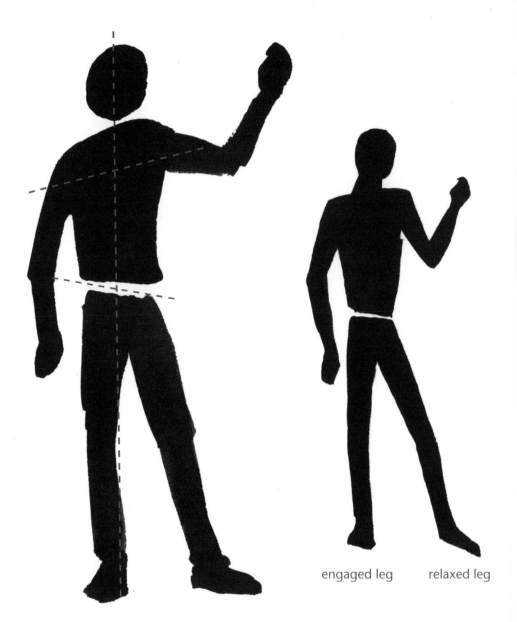

engaged leg relaxed leg

Contrapposto, which means "counterpose" in Italian, is the classical ideal of the standing figure in which movement and stillness are balanced. The figure stands with one leg holding its weight and the other leg relaxed. The hip and shoulder axes sit at opposite angles.

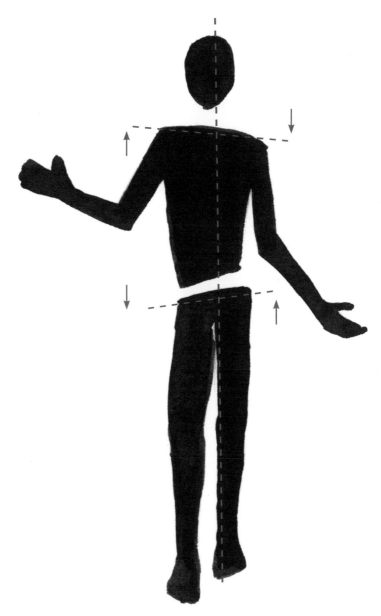

The hip of the engaged leg is pushed upward and
the shoulder declines. The relaxed leg is free of its weight-
bearing responsibility, and because the position of the hip is
lower, it seems a bit longer than the engaged leg.

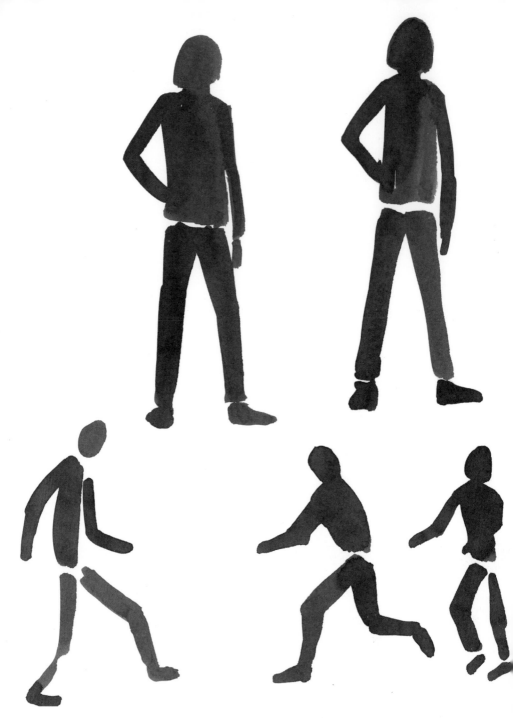

Change the alignment of the axes.

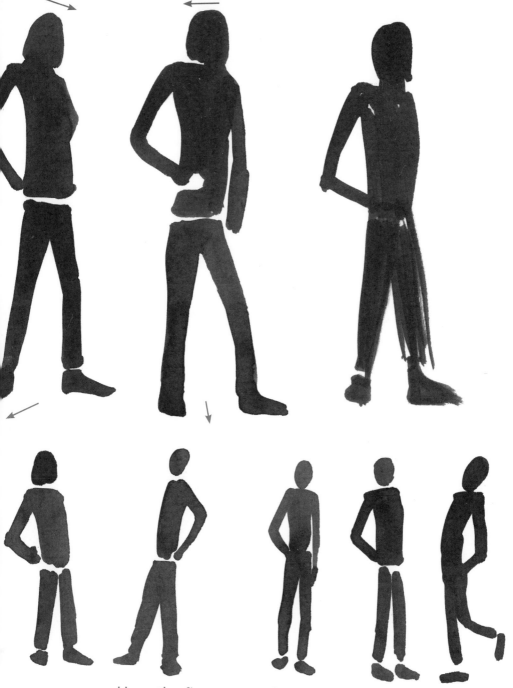

Have the figures stand with their feet planted firmly on the ground.

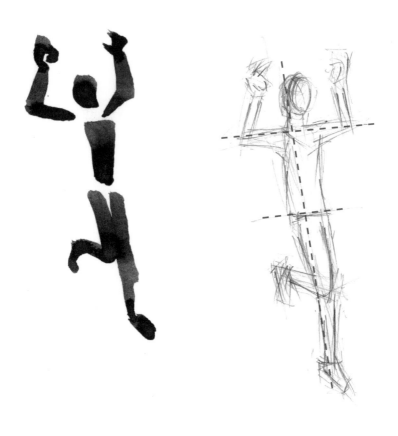

Expand the directional axes beyond the figure.

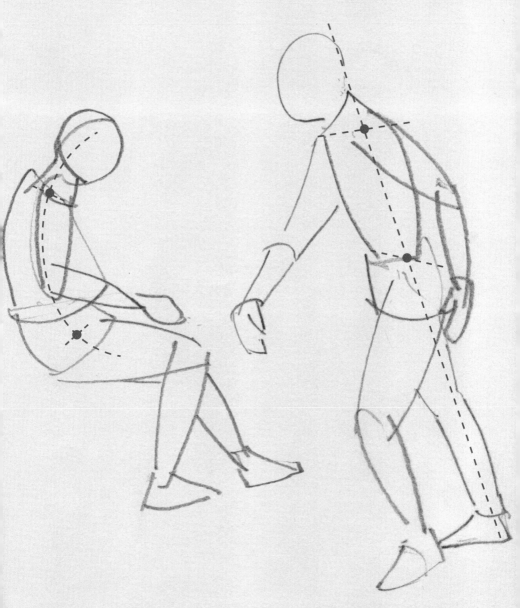

The more the figure is shown in a side view, the shorter
its hip and shoulder axes become.

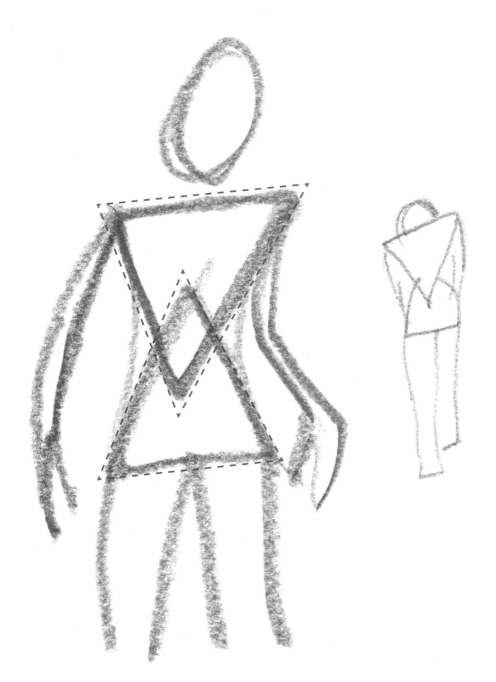

Construct the upper body with two triangles,
one inside another.

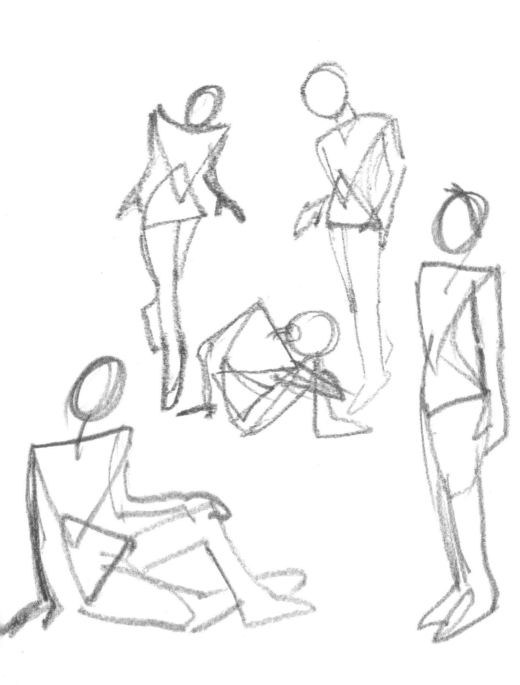

The connection between the triangles is flexible.

6. Measure

Measuring a body is a delicate affair. Idealism, reality, wish, and cliché can create a wide variety of contradictions. Besides aesthetic norms, dimensional ratio plays an important role when drawing bodies and faces in correct proportions. A simple unit, such as the size of the head or hand, is used as a proportion to measure the length or width of the other body parts. Where is the body center; how many times does the head fit into the height of the body?

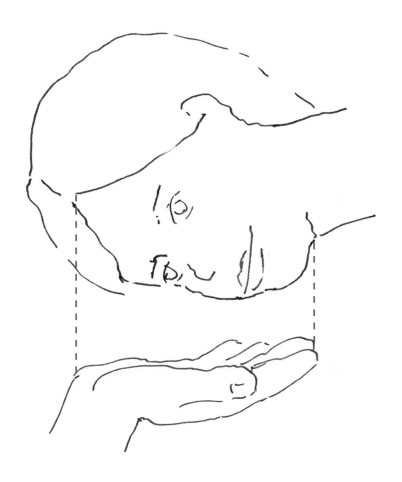

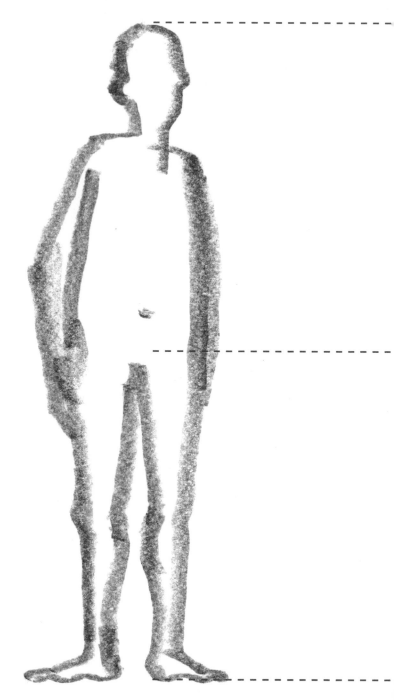

The body's center is between the navel and crotch.

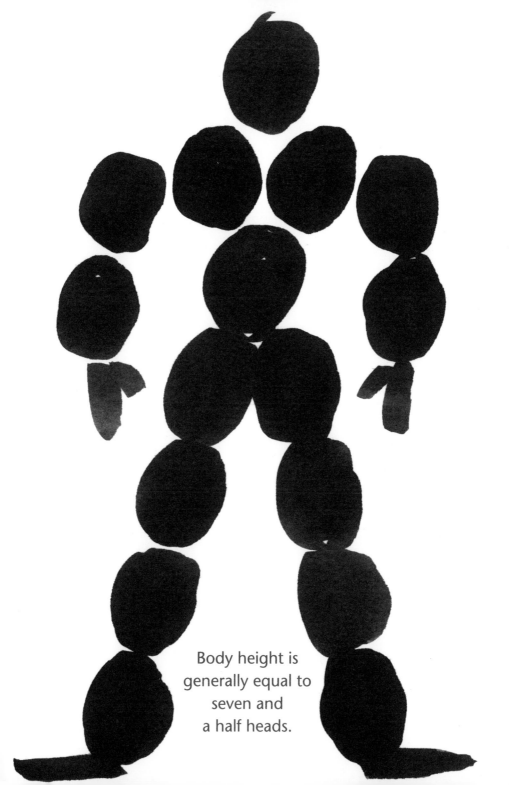

Body height is
generally equal to
seven and
a half heads.

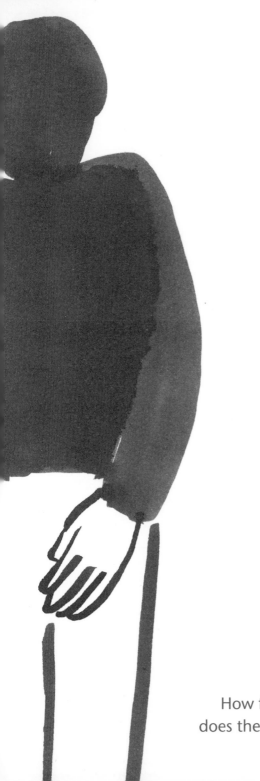

How far down
does the arm reach?

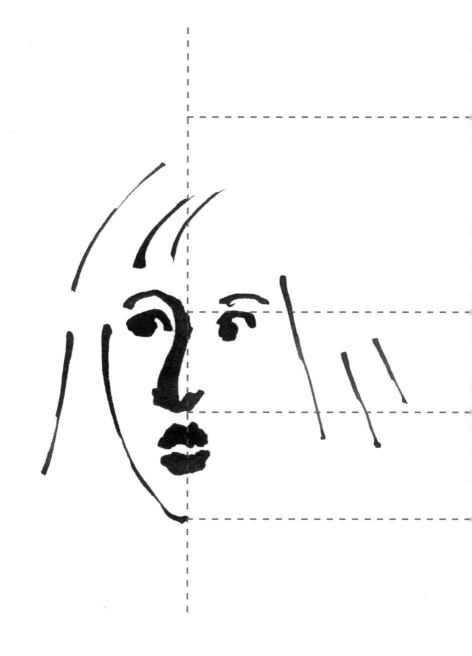

The eyes sit in the middle of the head. The length of the nose matches the distance from the chin to the tip of the nose.

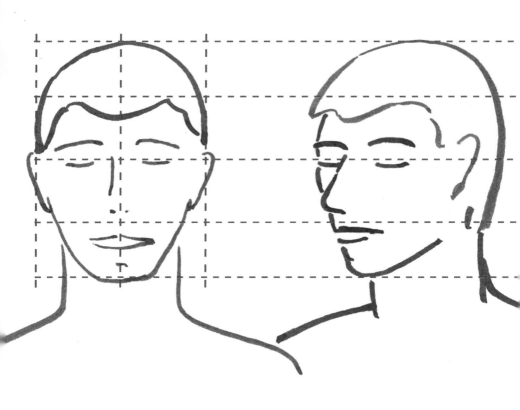

To move from a frontal view to a three quarters profile, the
distance between the nose bridge and the eye is shortened.
On the frontal view, the distance seems bigger because
the nasal bridge creates a distinct separation.

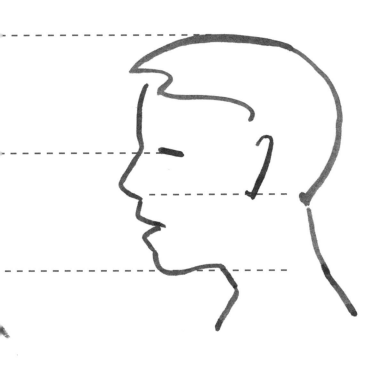

Make sure the back of the head isn't too small
in a profile. The neck is noticeably higher than the chin.

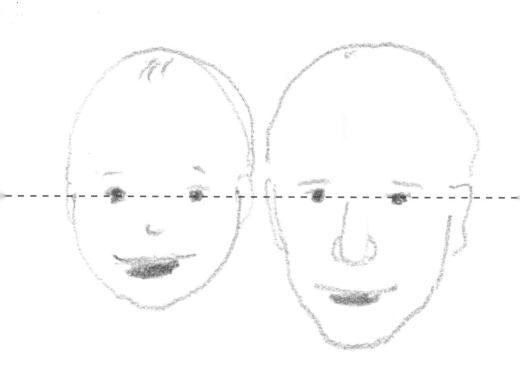

The round head and relatively low-placed eyes
create a childlike sketch.

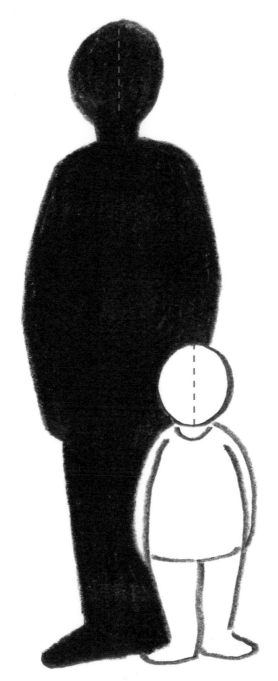

A child's head is proportionally bigger
to the body length than an adult's head is.

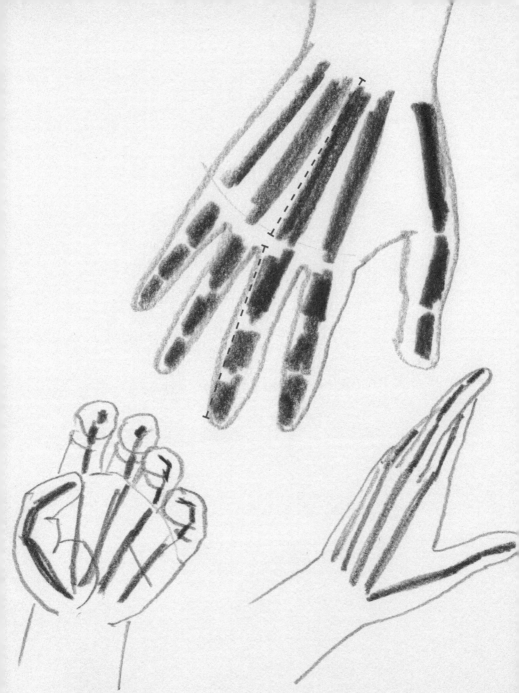

It isn't a complicated formula: The bones in the palm of the
hand are as long as the three finger bones together.

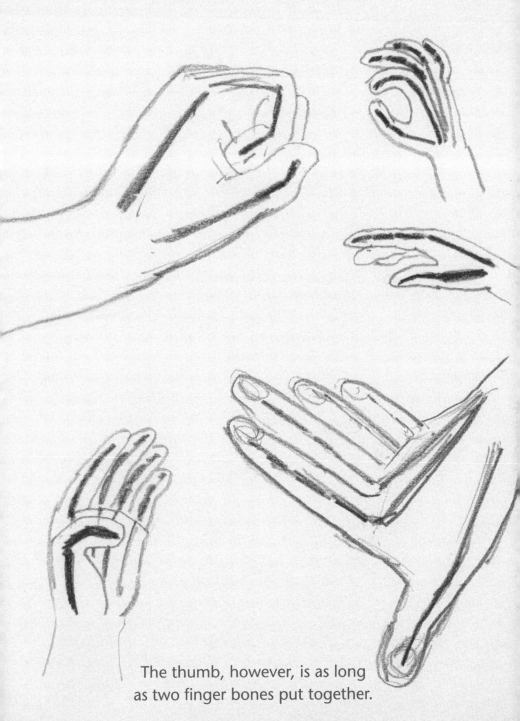

The thumb, however, is as long
as two finger bones put together.

7. Fill In

Common geometric shapes—such as triangles, trapezoids, circles, and arrows—are simple to draw. They serve as outside shapes into which a figure is fit. Even if the bodies seem a bit stiff at first, they have a compact, sign-like appeal. Once the figure is released from its geometric bonds, its shape is obtained. This playful approach of filling various geometric forms with figures tests the imagination and shows you how various body parts relate to one other.

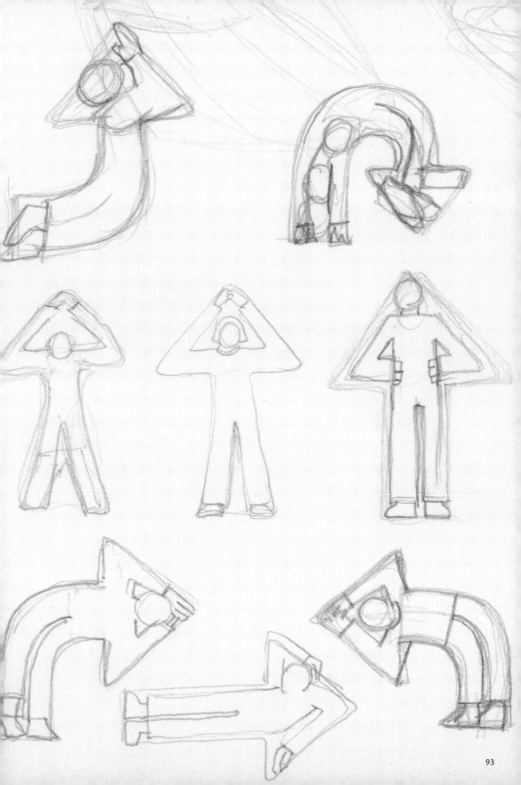

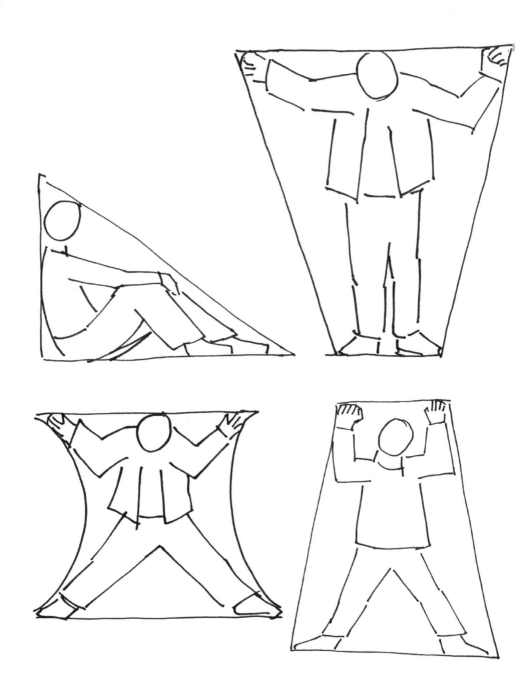

First sketch random geometric shapes.

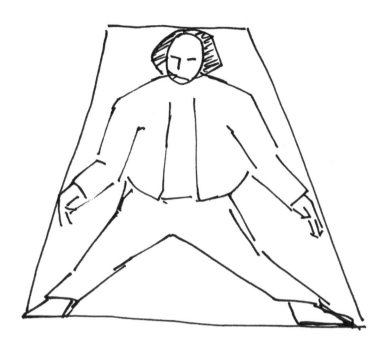

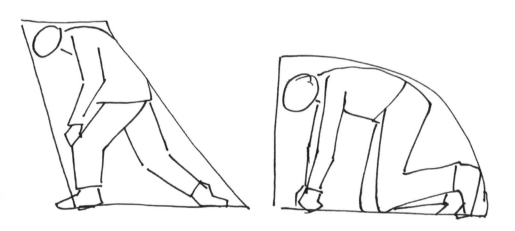

The idea of how a figure could fit into it
already emerges while drawing the outside shape.

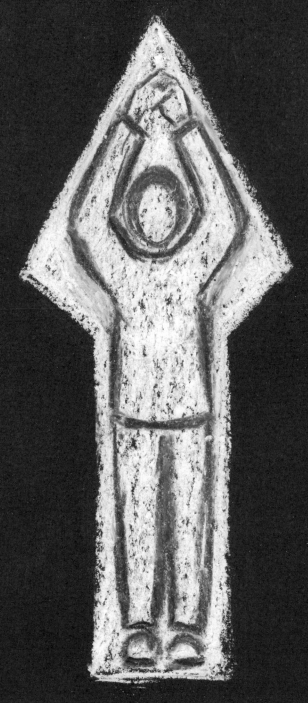

You can stretch the figure inside the arrow

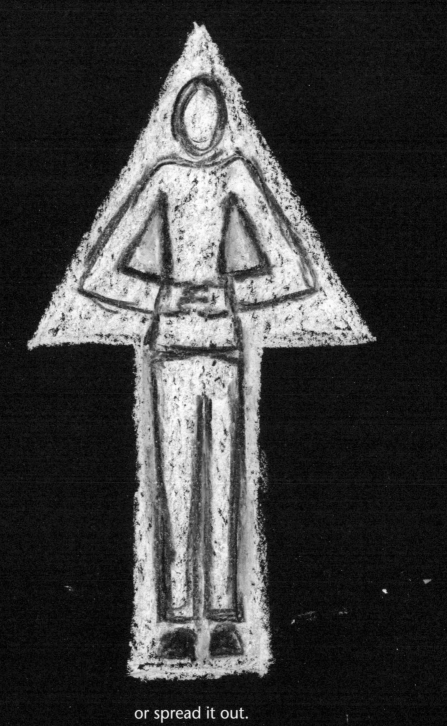

or spread it out.

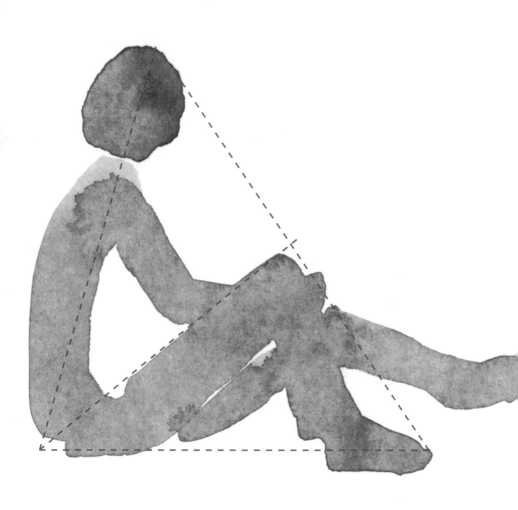

Even if the figure breaks away from the stiff basic
shape of the triangle, it still retains its basic geometry.

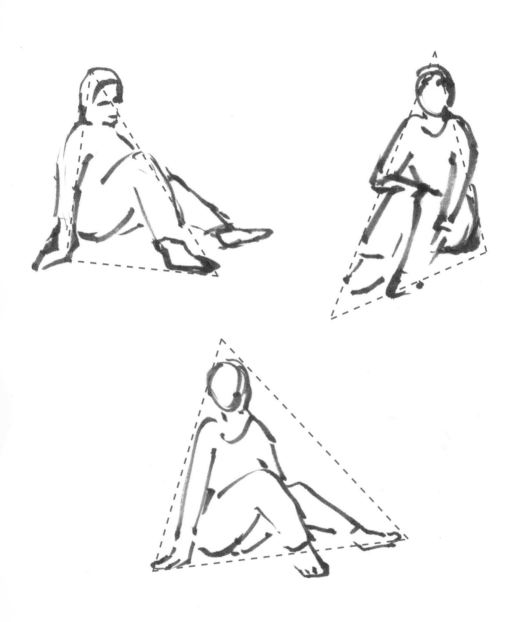

Triangles are helpful to align sitting, stable figures.

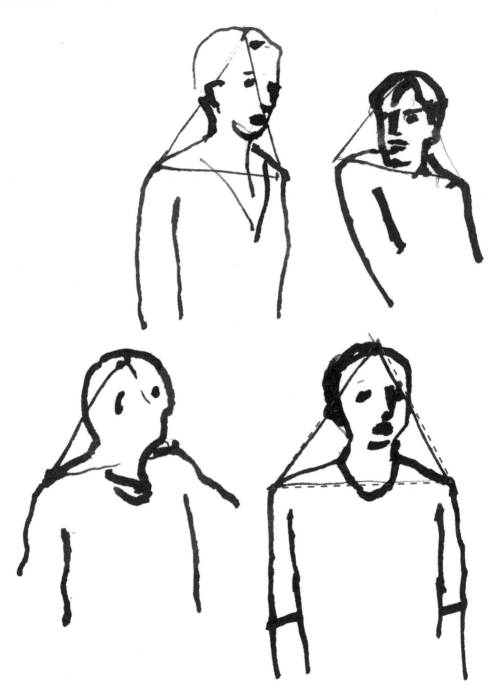

The points of the triangle line up with the upper tip of the head and the shoulders below.

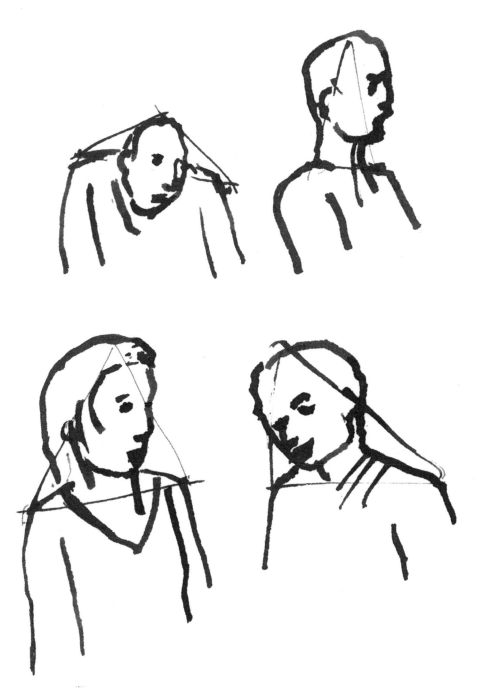

Place the head, neck, and nape within the triangle.

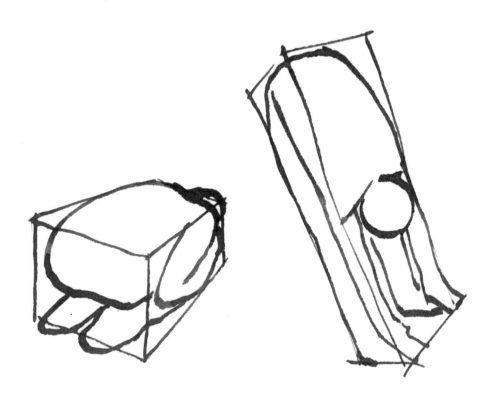

You can make the figure play hide and seek.

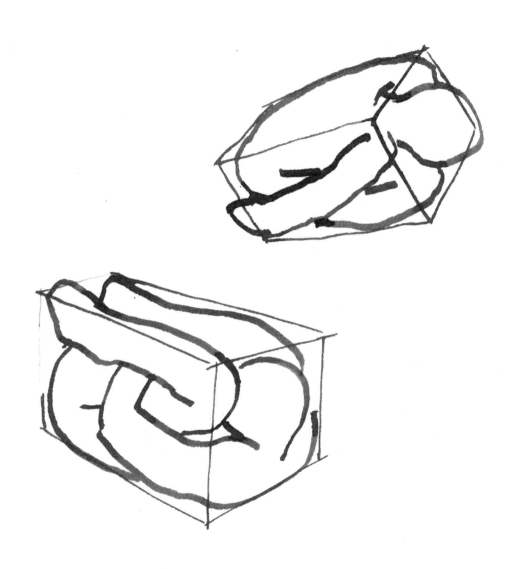

Scrunch up a figure to fit within the shape.

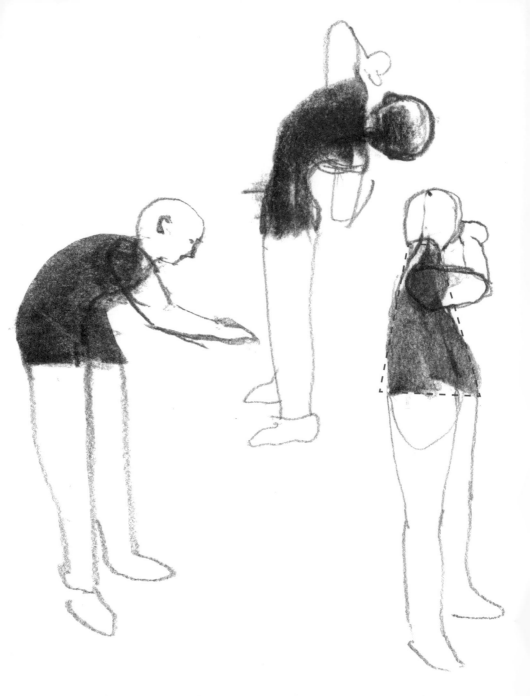

The trapezoid-like shape of the upper body helps
to visualize the turning and bending of the torso.

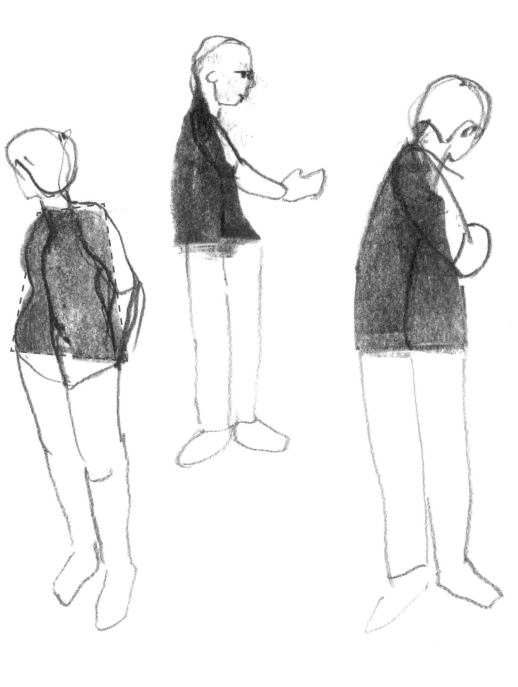

While drawing, stand up and try it yourself
to see how far you can turn.

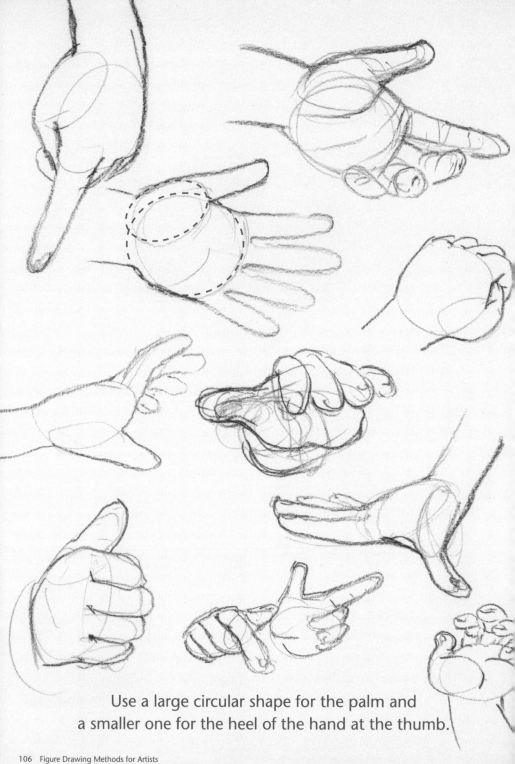

Use a large circular shape for the palm and
a smaller one for the heel of the hand at the thumb.

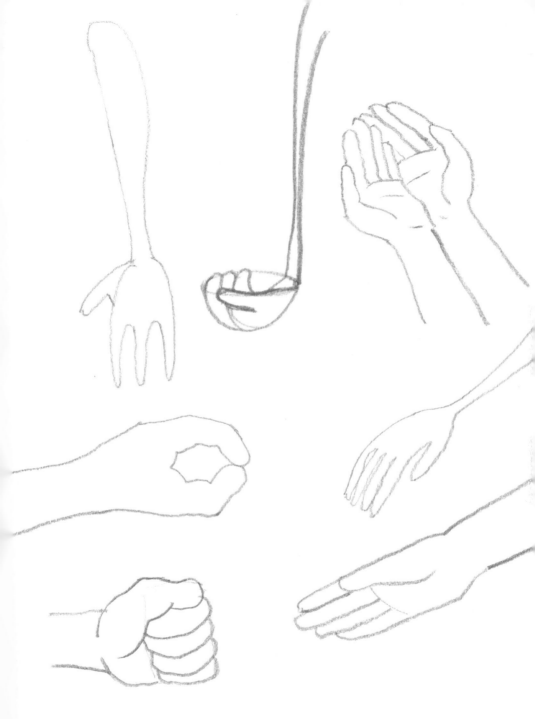

Isn't there a tool hidden inside every human hand?

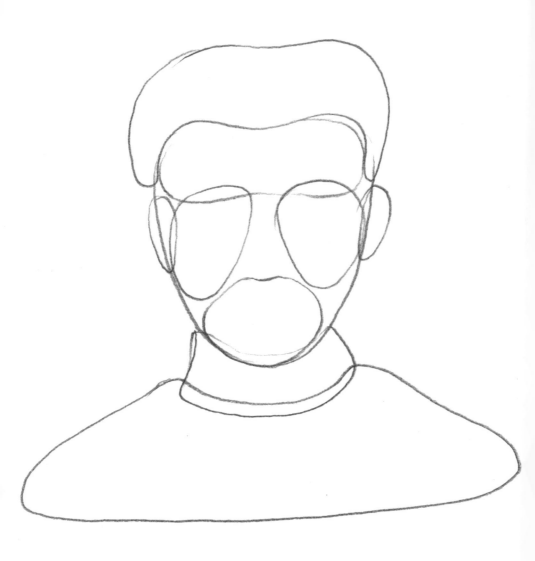

Divide the parts of the face without drawing
the nose, mouth, and eyes.

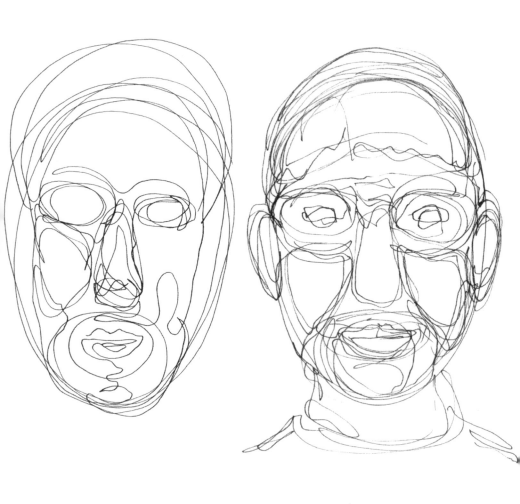

Use more shapes to differentiate the parts further.

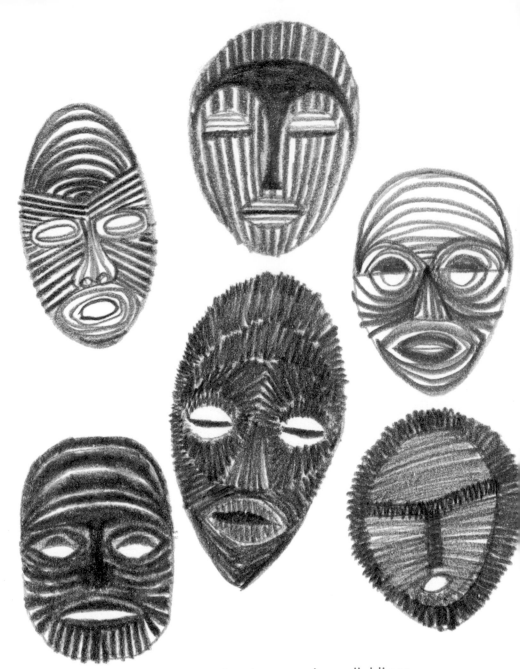

Hatchings, closely spaced parallel lines,
correspond with the real
facial features and turn into patterns.

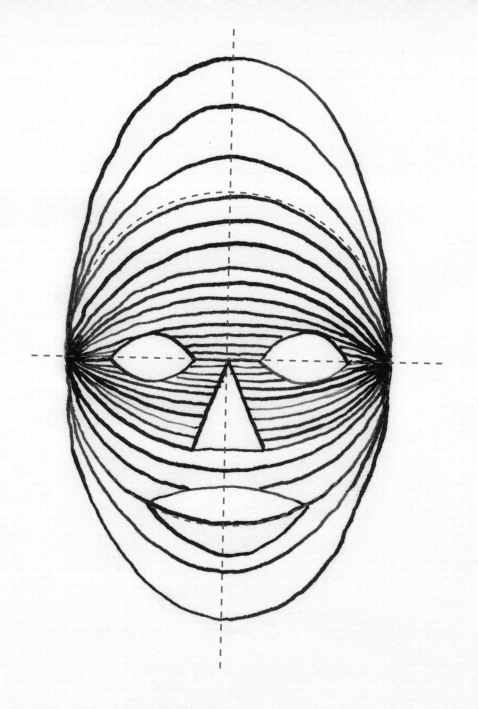

Use symmetry as a guide.

8. Bend and Stretch

Many archaic human depictions are static and show a more symbol-like portrayal rather than a lively one. With the increasing demand for realistic pictures, the ingenuity of design also developed further. Muscles bend and stretch, the spine curves and turns, and the focal points move. This creates momentum and tension. One difficulty while drawing moving figures is to bring them into harmony with your imagination. Therefore, you need overlapping, directional changes, and foreshortening (angling the figure so it appears closer to the viewer). You can depict a moving figure with an open line that follows the movement or by using a constructed approach in which the joint points are laid out first.

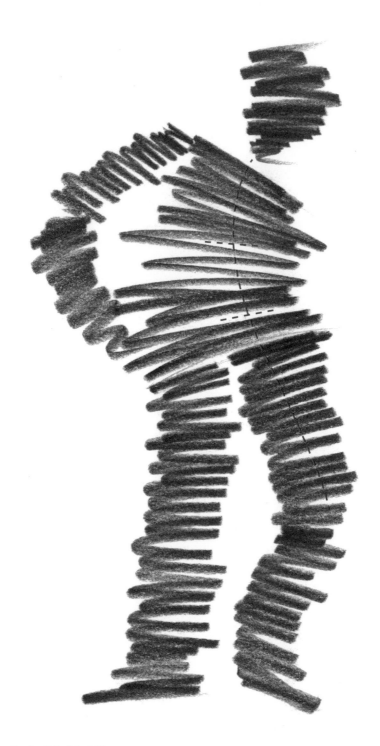

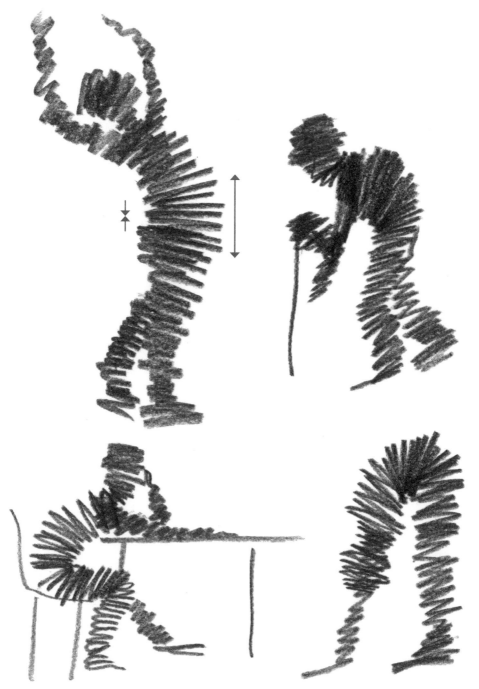

From an accordion to a body: The more condensed areas
are at the bends, as opposed to the stretched ones.

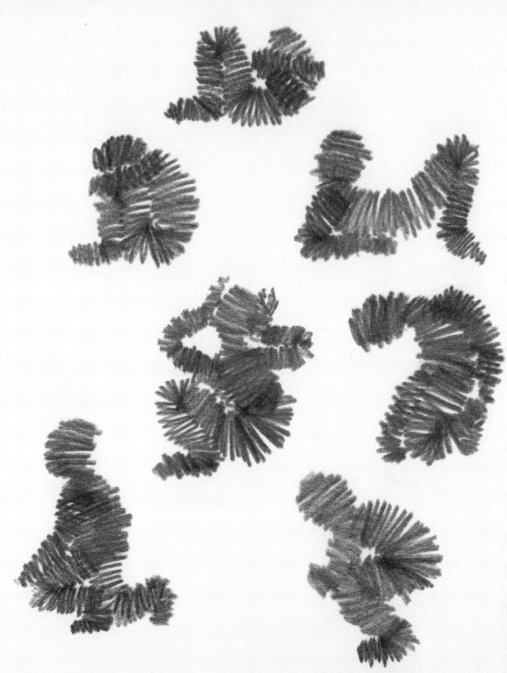

Even complicated poses can be solved
with the accordian method.

Observe how changes in posture
are determined by the bending of the spine.

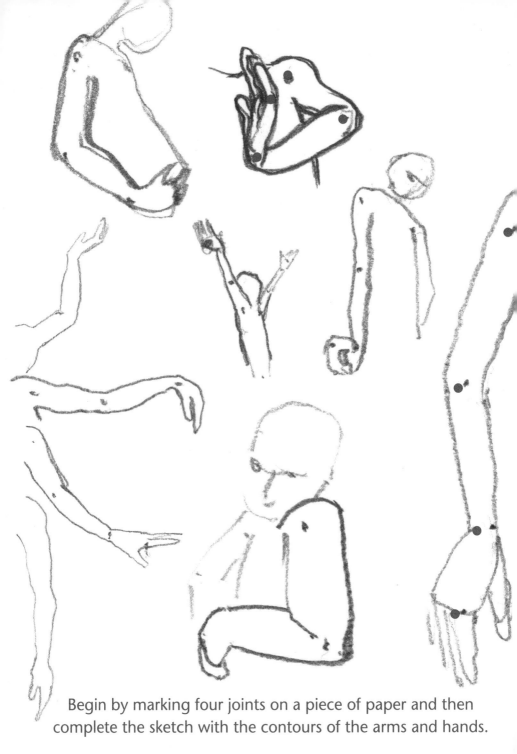

Begin by marking four joints on a piece of paper and then complete the sketch with the contours of the arms and hands.

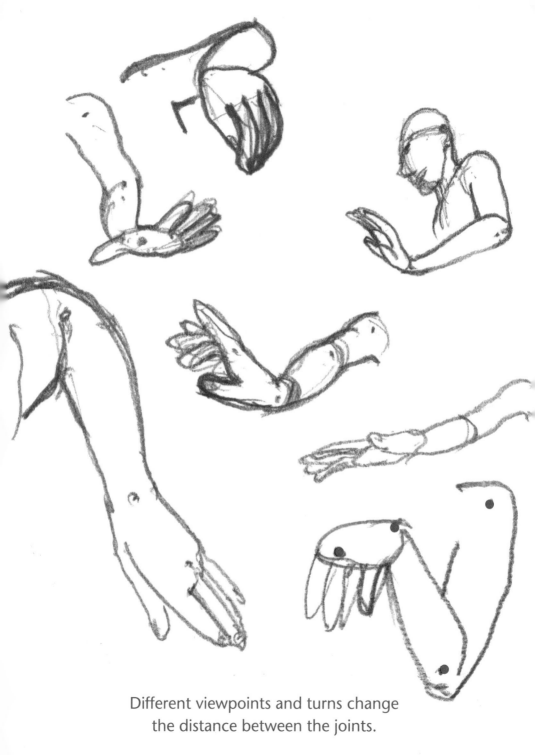

Different viewpoints and turns change
the distance between the joints.

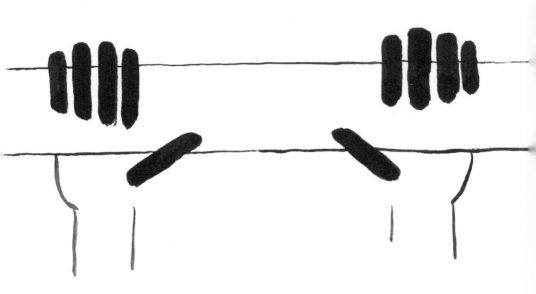

Human hands grip, thanks to opposable thumbs.

Without thumbs, we could barely hold a tool;
our fine motor skills would be restricted.

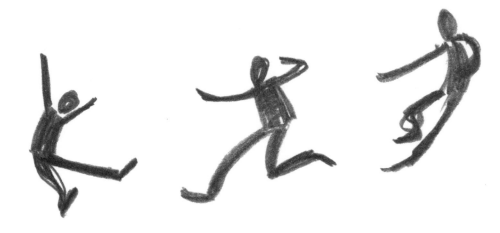

While sketching phases of movement,
forgo details to avoid being slowed down.

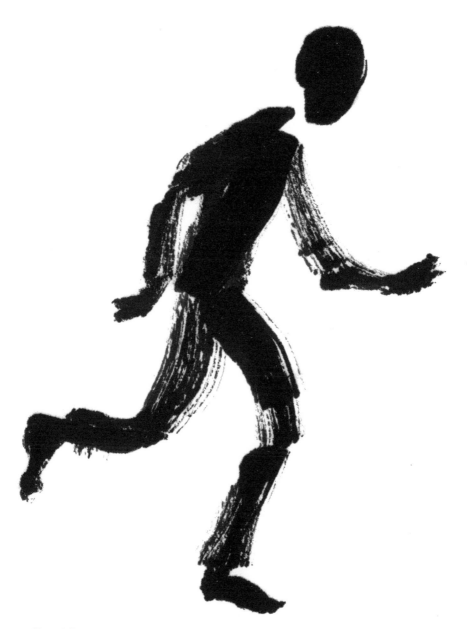

Decide which view is most effective. The runner here
is more recognizable when viewed from
the side rather than from the front.

9. Curves

The human figure is rich in curves. Lines swing and bend distinctively around the shoulders, belly, breasts, and waist. The arms and calves are long stretching waves, while the toes are short ripples. While drawing a figure, we think of sweeping bends instead of sharp edges; the body becomes smoother and the form moving. Depending on format, the wrist, the forearm, or even the whole arm fulfills the drawing movement and makes the line dynamic.

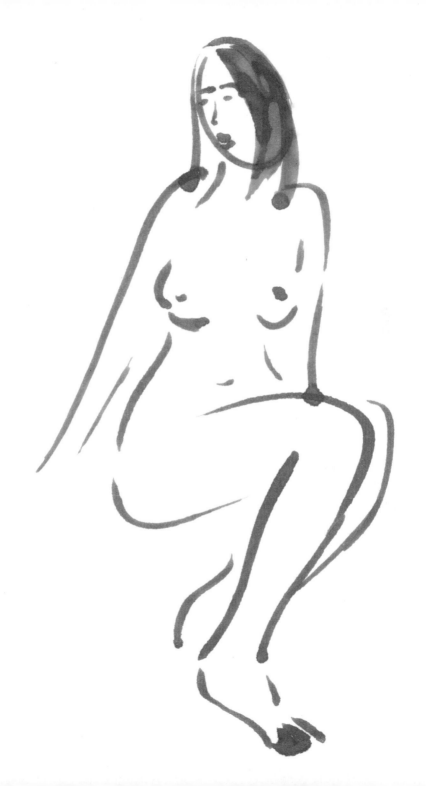

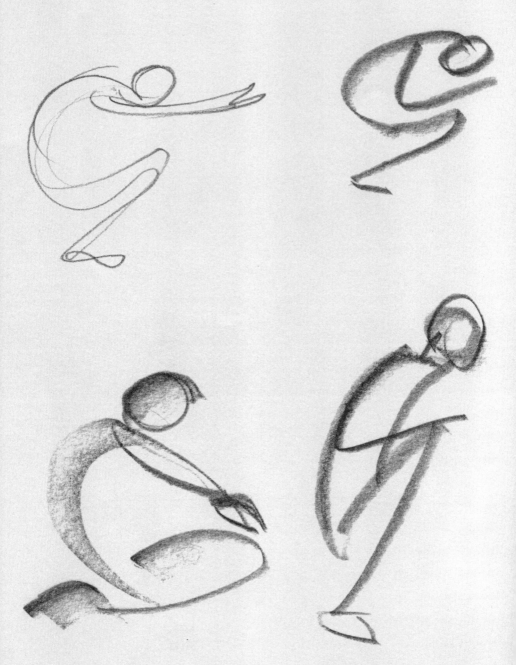

Try drawing steep curves.

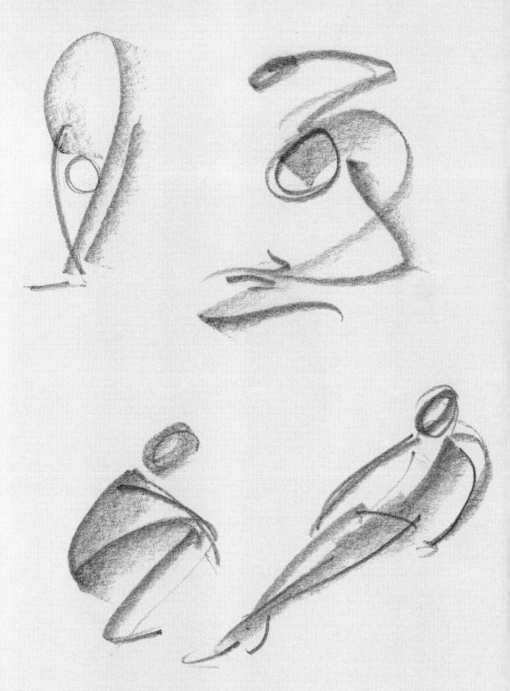

Draw quickly without thinking first.

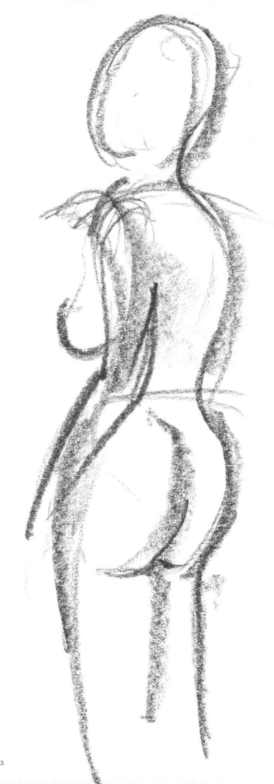

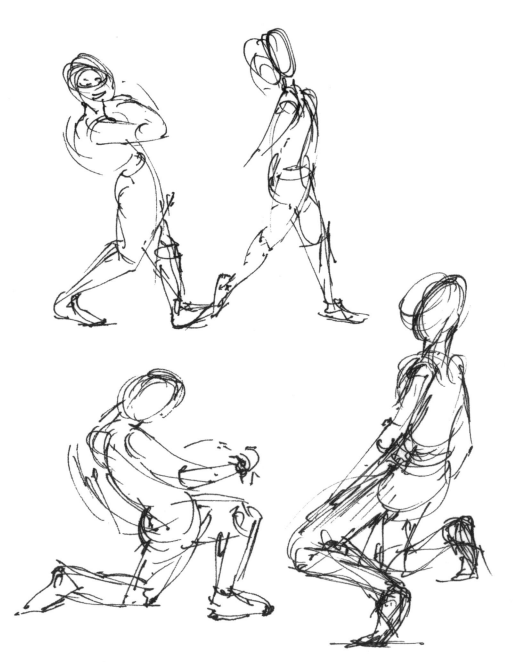

Describe movement with circular lines.

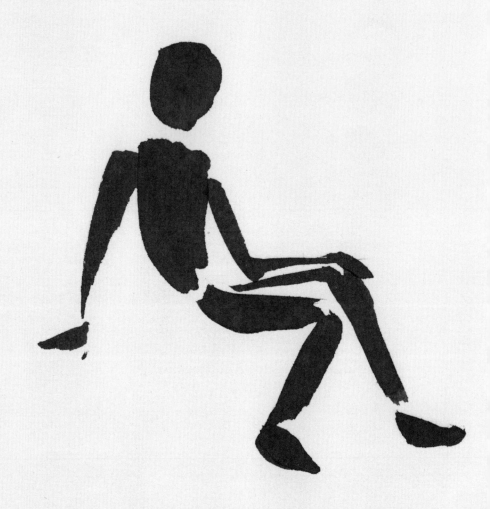

Tools can be sources of inspiration.
Japanese brushes, for example, are so soft that
the width of the line can be varied distinctively.

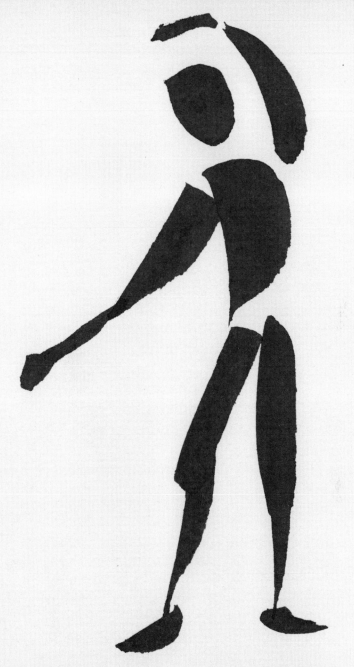

While painting motion, try varying the pressure
you put on the brush; natural curves will
emerge almost automatically, such as at the calf.

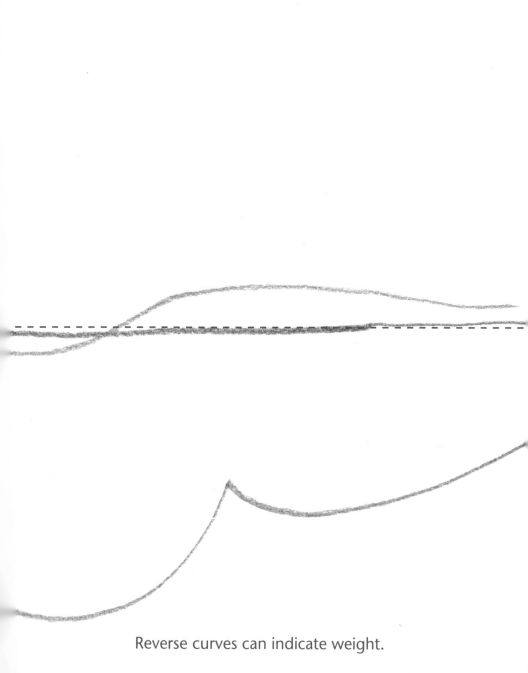

Reverse curves can indicate weight.

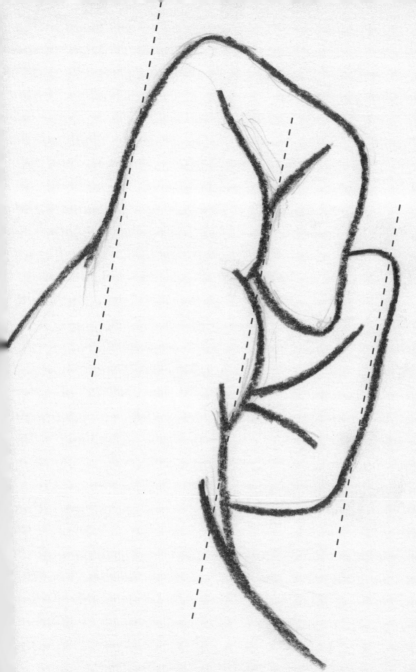

Finger joints, elbows, or knees all have characteristic curves
and folds. The contours of the body are convex and
concave lines, differing from fixed straight lines.

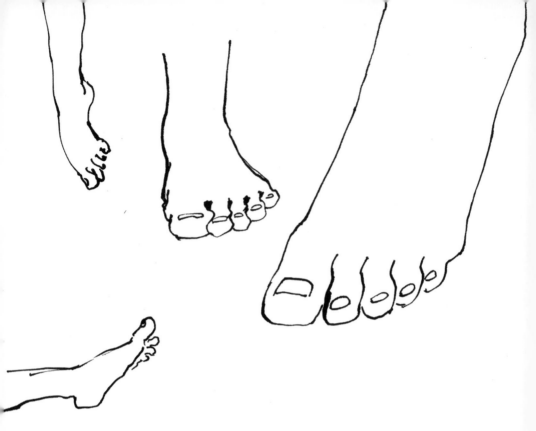

Count the joints of the toes on your own foot.
Where do they bend, widen, or tighten?

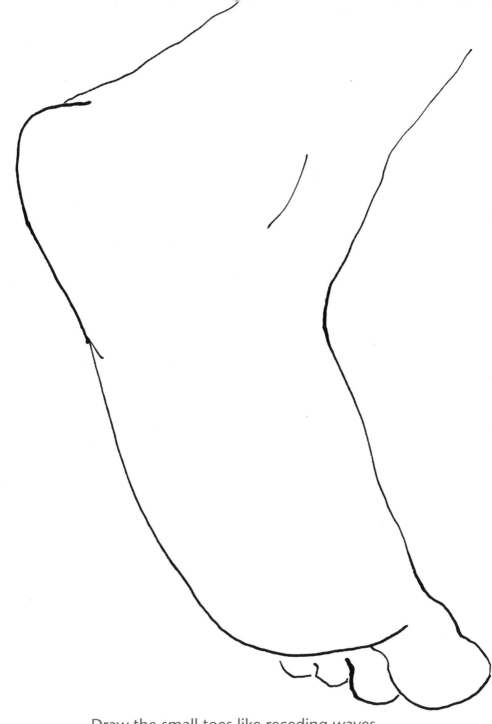

Draw the small toes like receding waves.

10. Bandage

Just like a bandage is wrapped around a body, a line can be, too. The drawing movements are circular, swinging, and quick rather than tentative. The imagination of a body's shape dominates the drawing, not the outlines or anatomic integrity. Through the encasing bands and loops, the body parts obtain volume. Even if the bandages are only partially applied, this method supports a sculptural look and dynamic. During the drawing of the face in half profile, staggered ellipses (tilted, flattened circles) create a helpful structure for the positioning of the nose, eyes, and mouth.

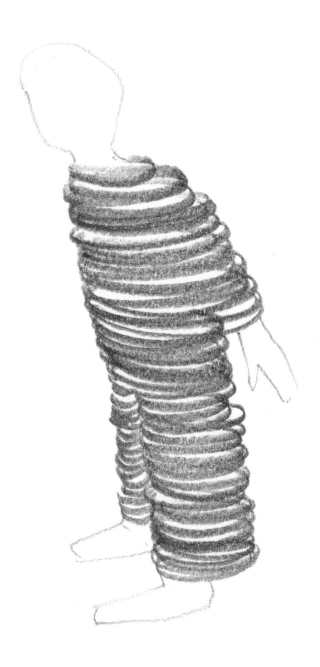

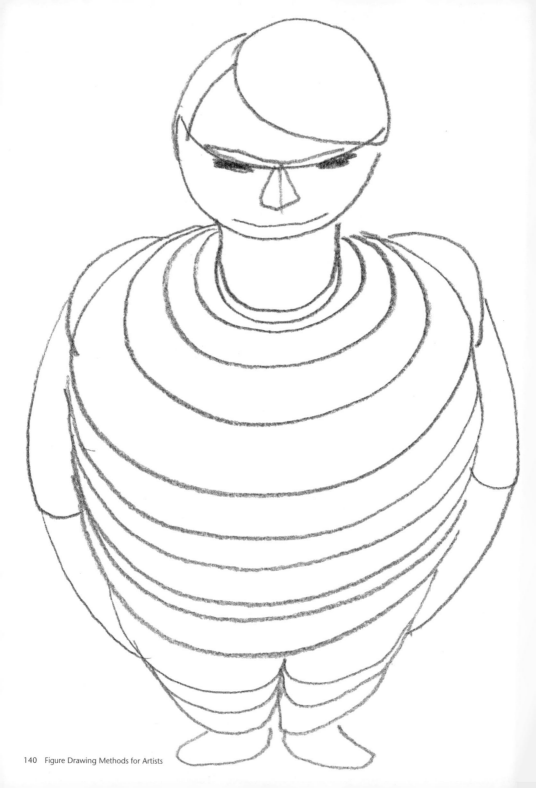

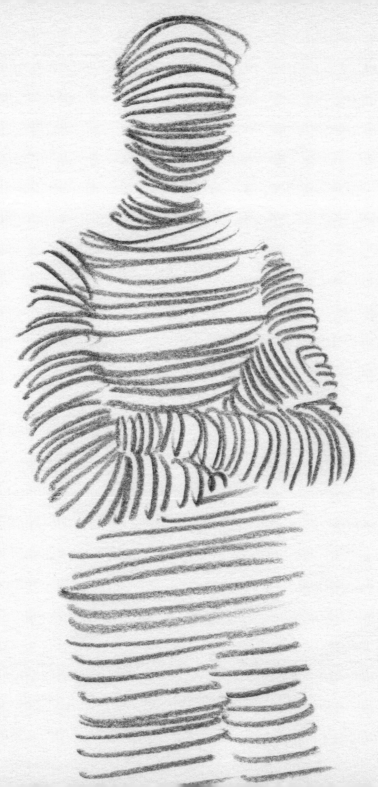

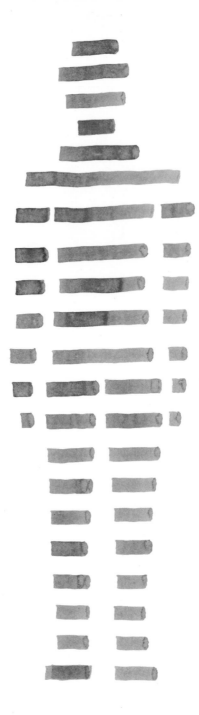

Find the appropriate proportions using horizontal lines.

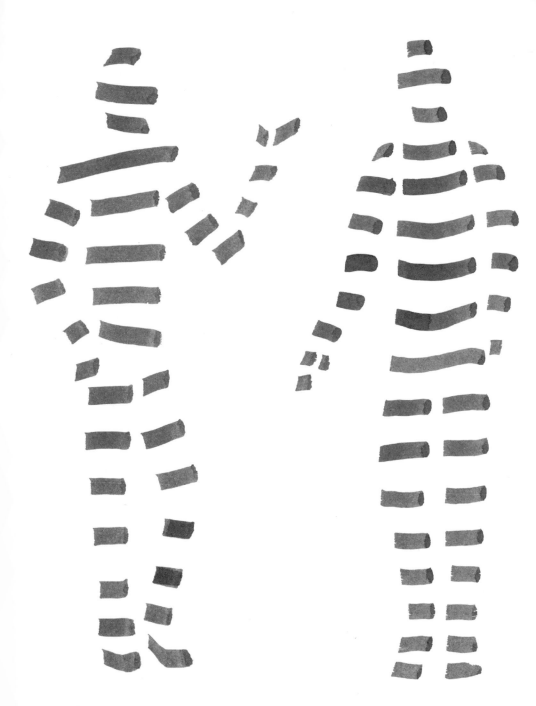

The stripes align with the movement of the body parts.

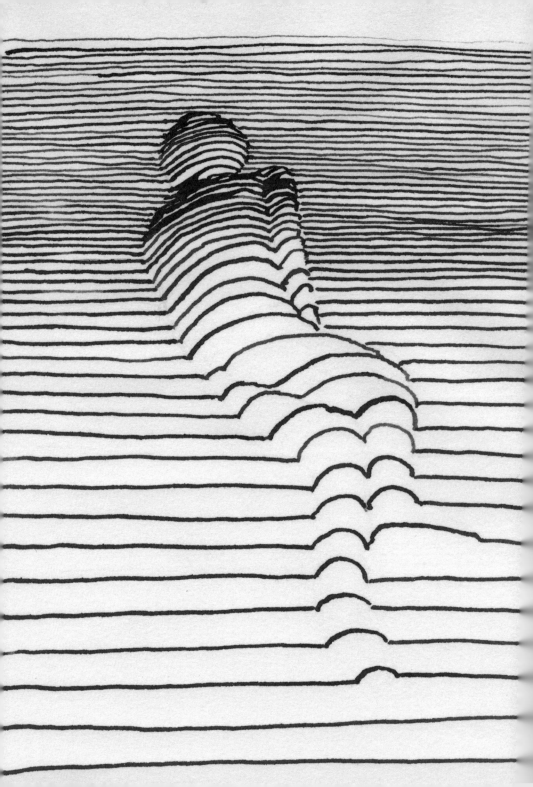

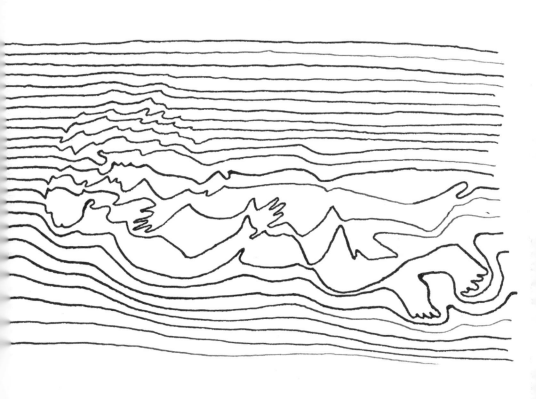

Experiment with the ideas of bandaging:
Lines are drawn from one side to the other
to create shapes and therefore can't overlap.

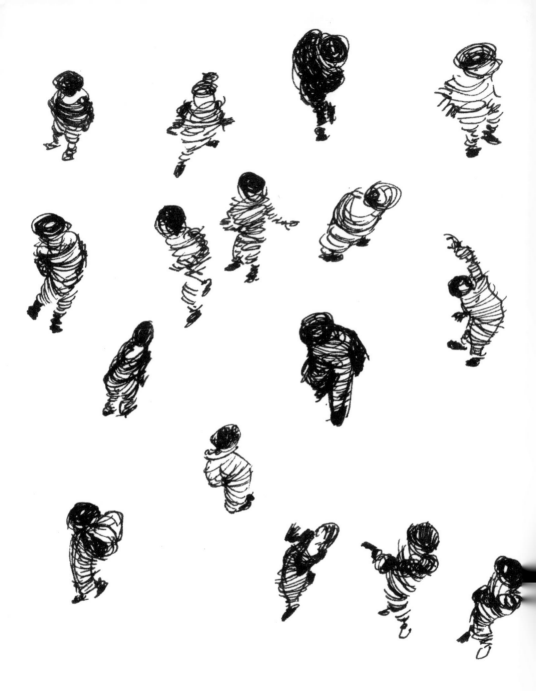

Take on the bird's-eye perspective and let the circles
become smaller from head to toe.

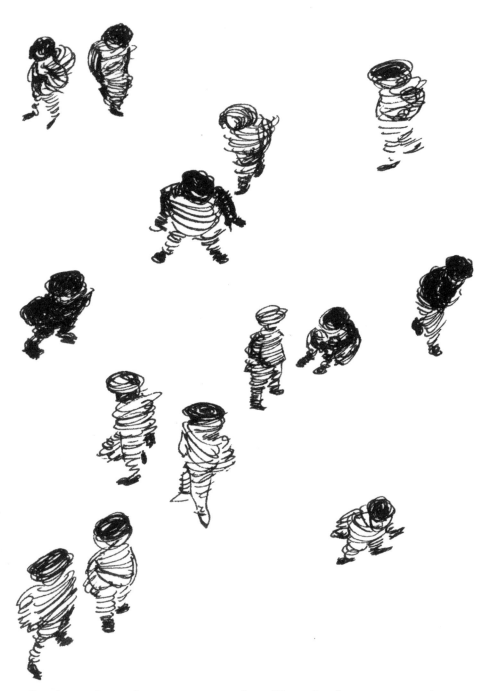

Or draw the other way around, coiling the loops upward.

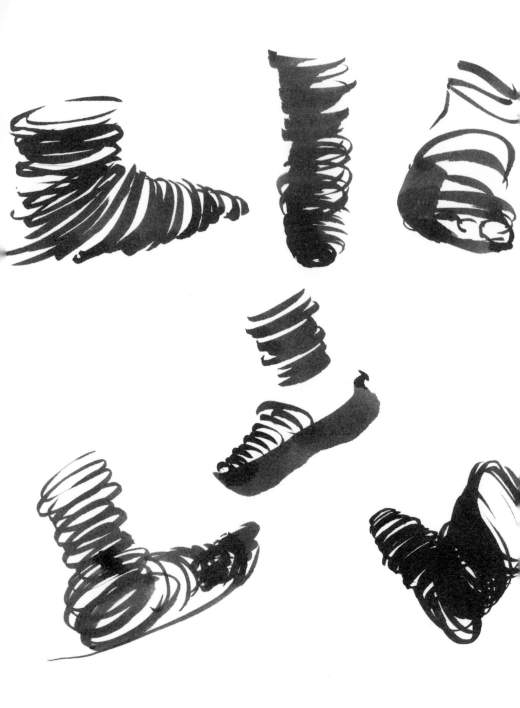

While bandaging, think of socks, boots, and sandals.

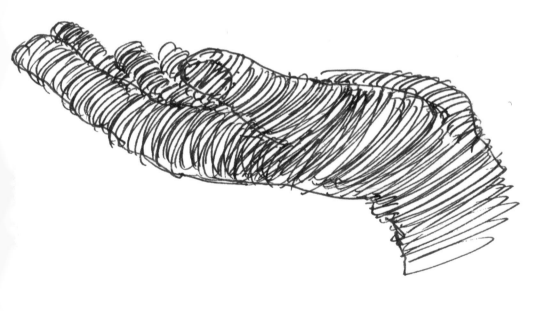

Note how this bandaging is wound and contoured.

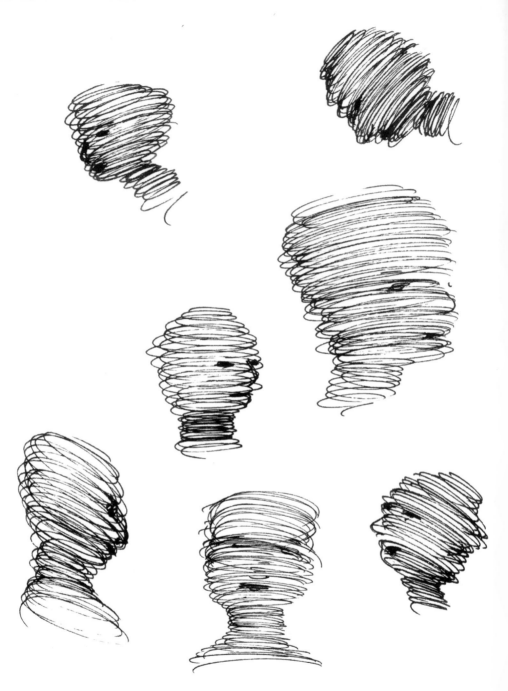

With a circling pen, create a head shape
and draw in the face.

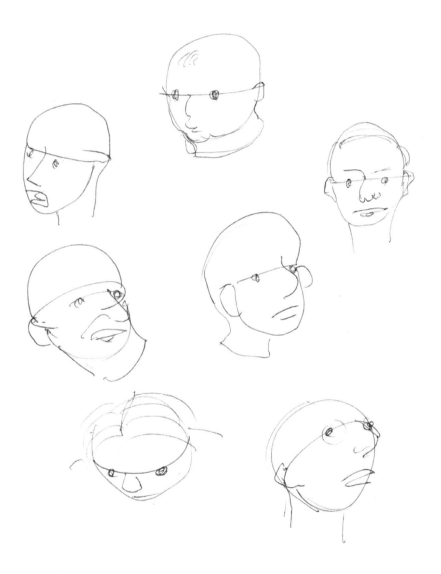

Even for odd head shapes, an ellipse is helpful
to position the head's center and eyes.

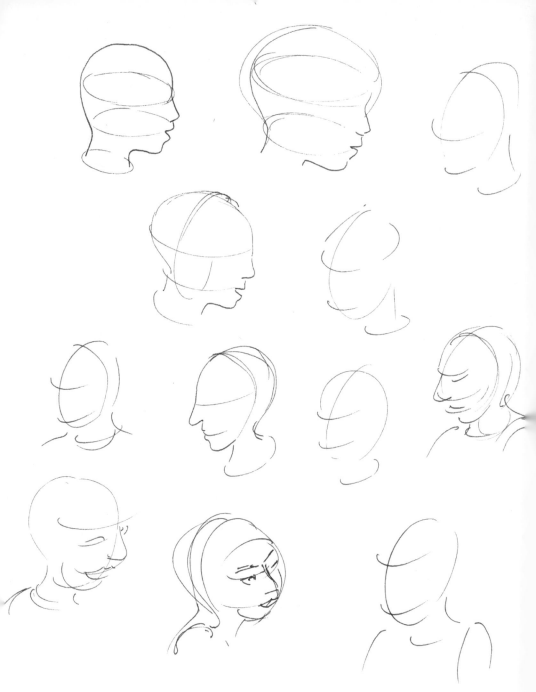

Three to four ellipses determine the alignment of all facial
parts. The eyes, nose, and mouth sit like orbiting planets.

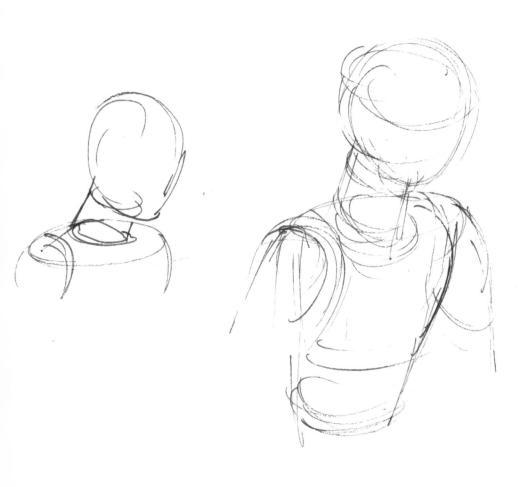

Put the head, neck, and shoulder together as with a doll.

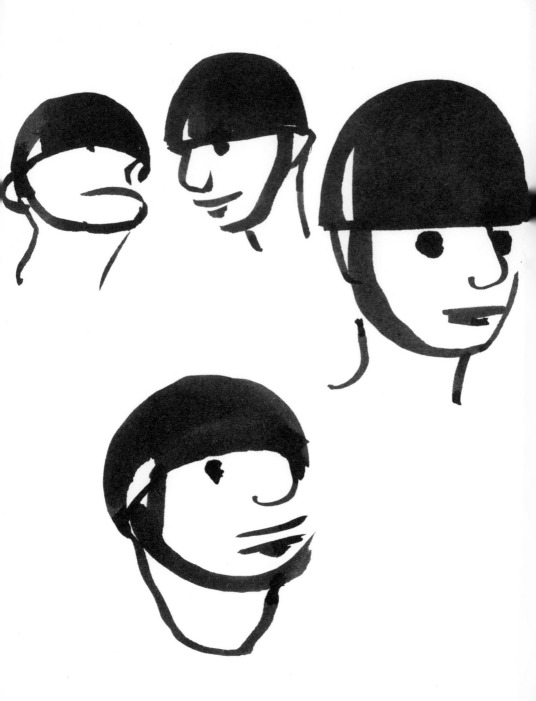

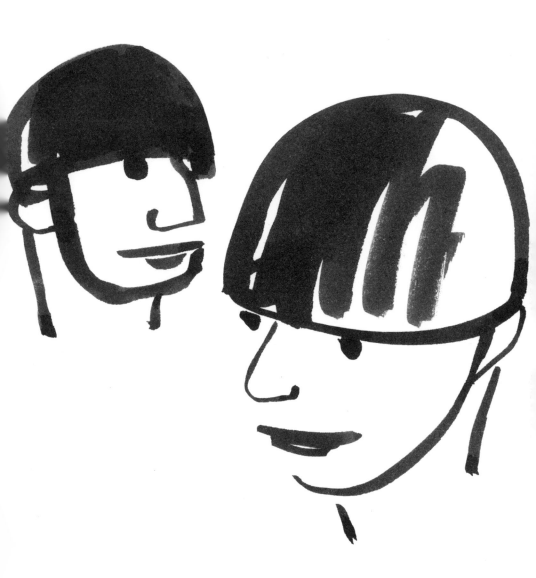

The helmets simplify the imagination of
sculptural head shapes.

11. Facial Expressions

Every face is different and changes expressions with moods, tempers, and emotions. Facial expressions send signals that we can read and interpret. We can easily differentiate the emotionally moved face from the fixed, inanimate mask. The drawn visage is interpreted as a person. The bow of an eyebrow, the line width of the lips, a sudden wrinkle in the forehead: These are nuances that give a face character. Subtle nuances decide whether a laugh is hearty or sardonic. It could easily turn into a grin. It is more the organic interaction of all the parts that make it successful than the correct rendition of each part.

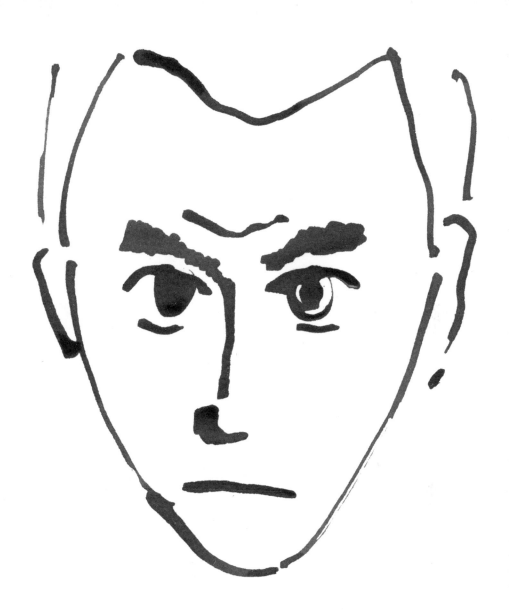

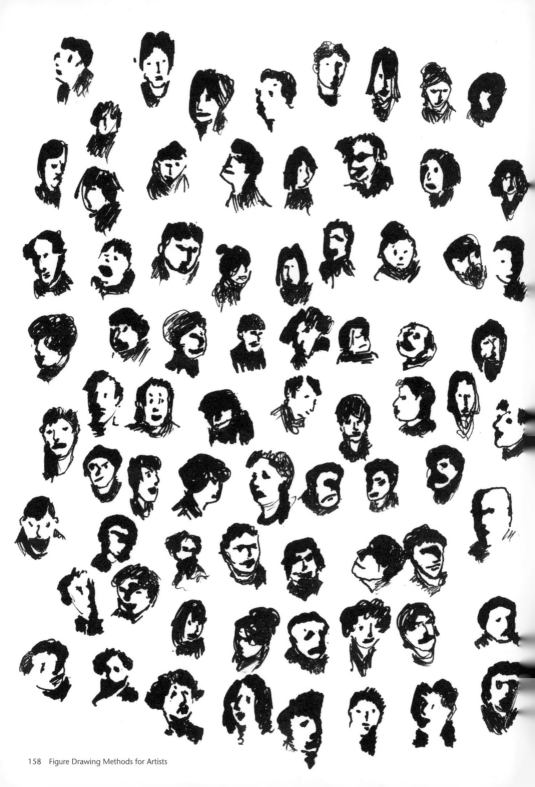

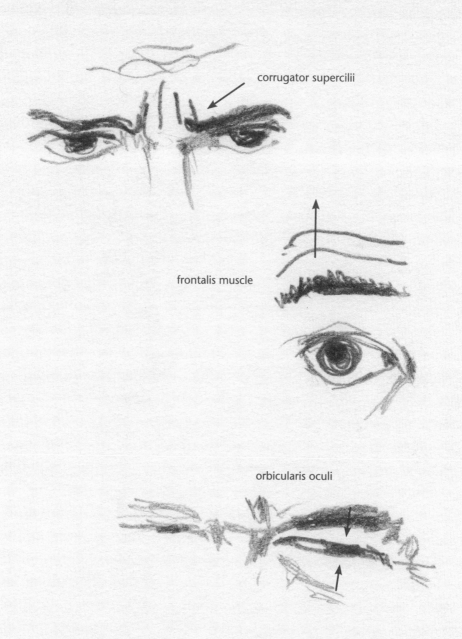

corrugator supercilii

frontalis muscle

orbicularis oculi

Muscle movement creates facial expressions.

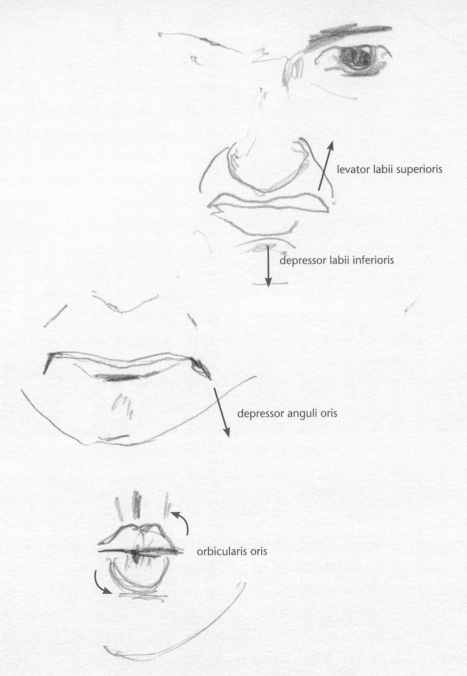

levator labii superioris

depressor labii inferioris

depressor anguli oris

orbicularis oris

Observe your facial muscles in a mirror
and draw different emotions.

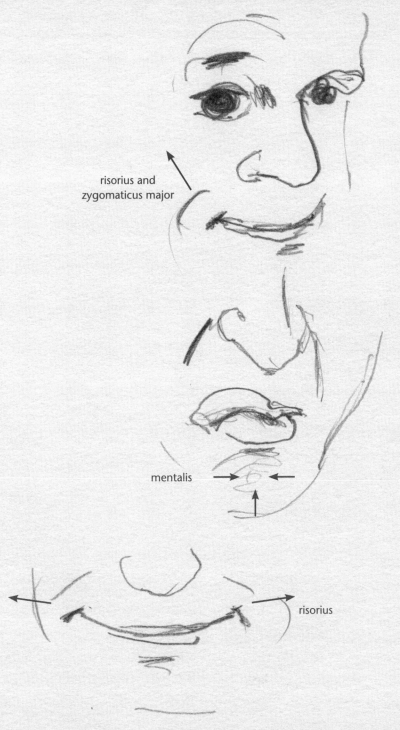

risorius and
zygomaticus major

mentalis

risorius

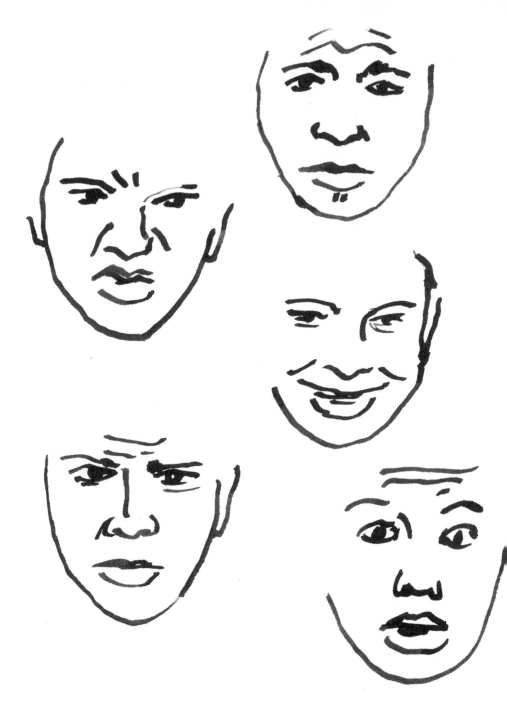

The coming together of all the parts decides the expression.

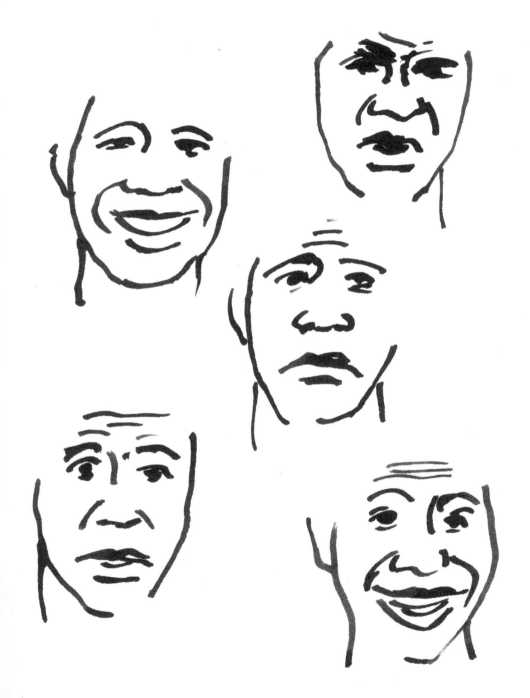

Don't be afraid of wrinkles.

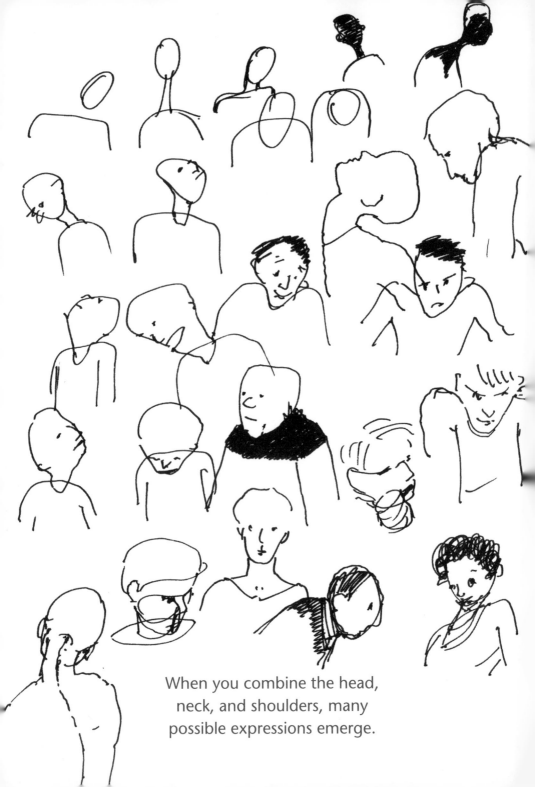

When you combine the head, neck, and shoulders, many possible expressions emerge.

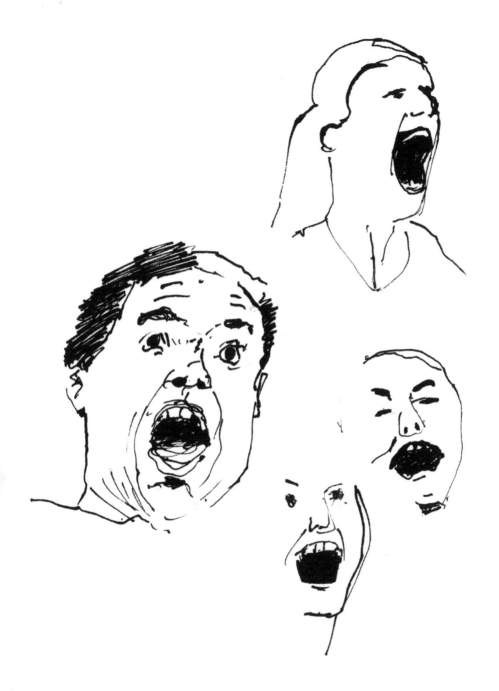

Once the lower jaw goes into action, the
head becomes distinctively more expressive.

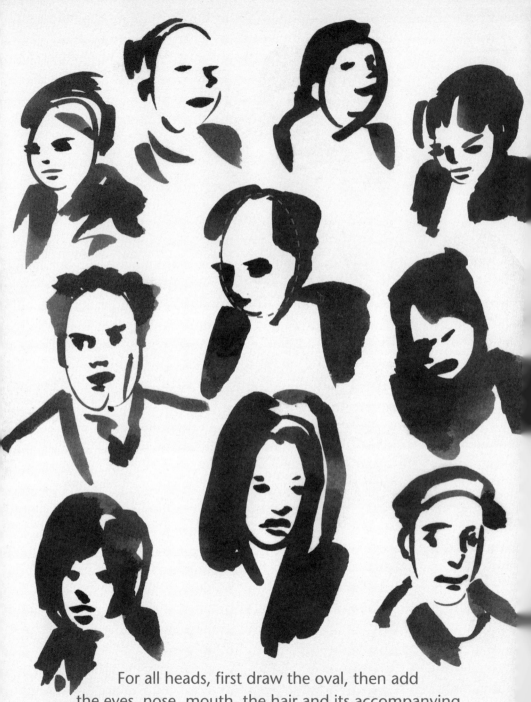

For all heads, first draw the oval, then add
the eyes, nose, mouth, the hair and its accompanying
shadow, and a hint of the lower neck and upper body.

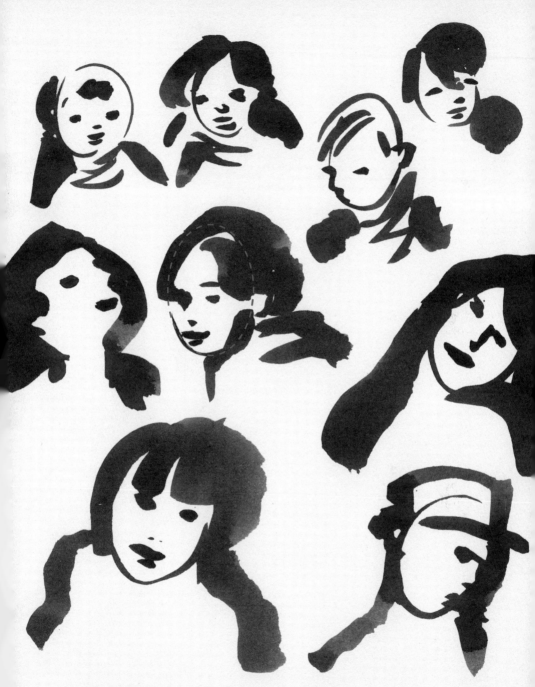

Vary the nose area and paint the mouth
with one or two lines.

12. Improvise

When in the moment, let something unplanned emerge and be led by the process. This opens up new possibilities during drawing: one line leads to another, a brush stroke opens up space for associations, and so on. While creating, we make interpretations—a breast, leg, belly, or a hump. We create spontaneously, instead of following a finished idea. The risk of something going wrong is always a possibility, therefore, improvising simultaneously requires looseness and concentration. The prerequisite for this is collecting and developing ideas. Simple, made-up rules steer the process; they release the pressure to be imaginative. Improvising means not knowing what is coming next.

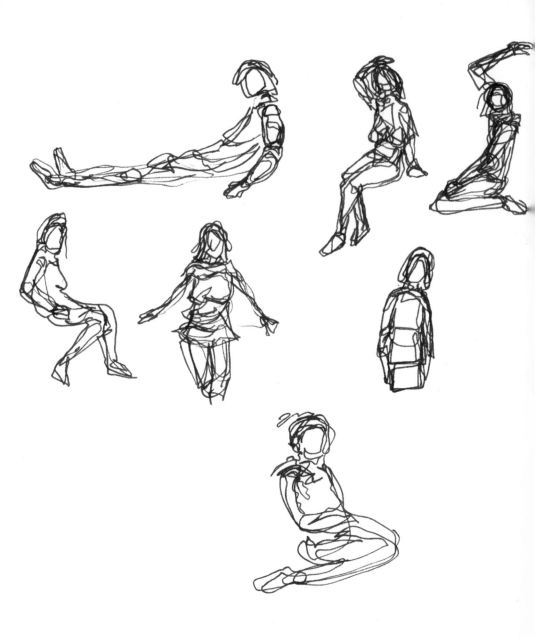

In the beginning, all possibilities are open.

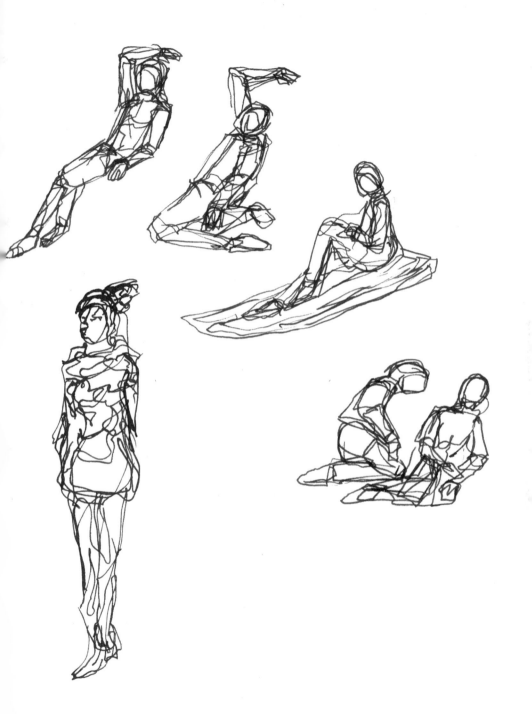

Improvisation only emerges while rendering a sketch.

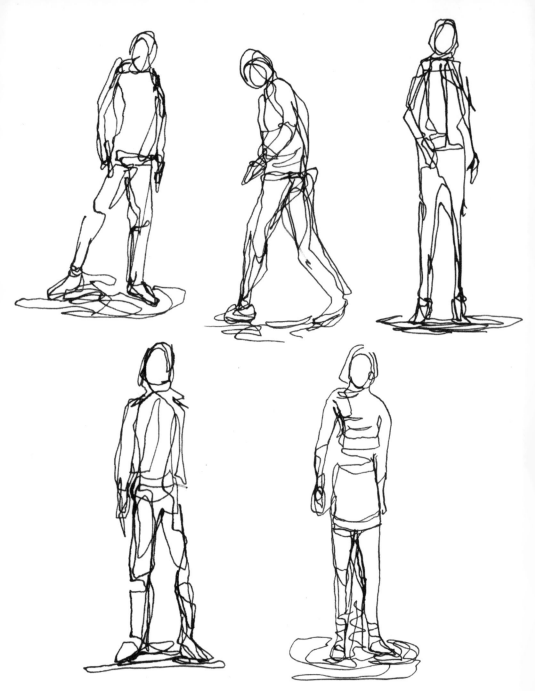

Using a fountain pen, create the figure in one fluid motion
as if laying down a string on a piece of paper.

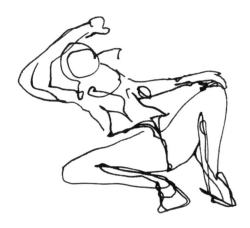

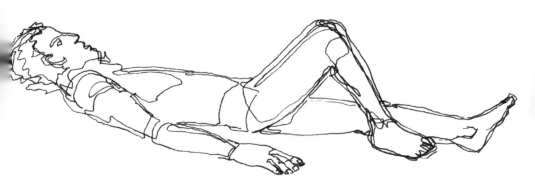

Find and create contours.

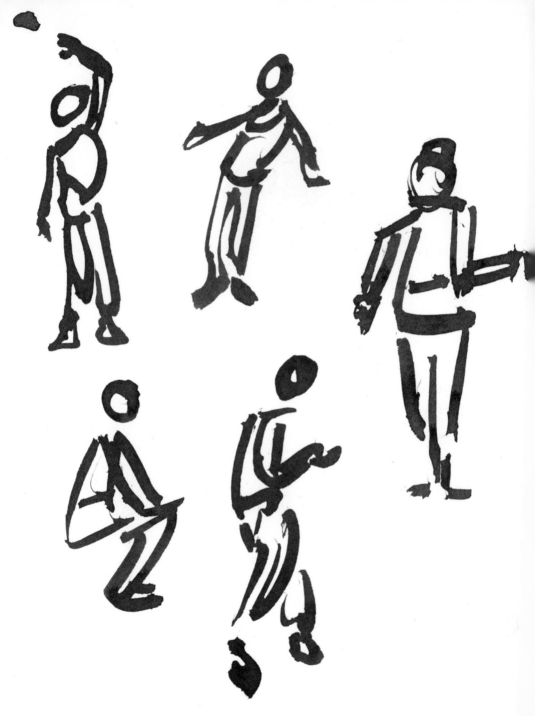

These figures depict quickness.

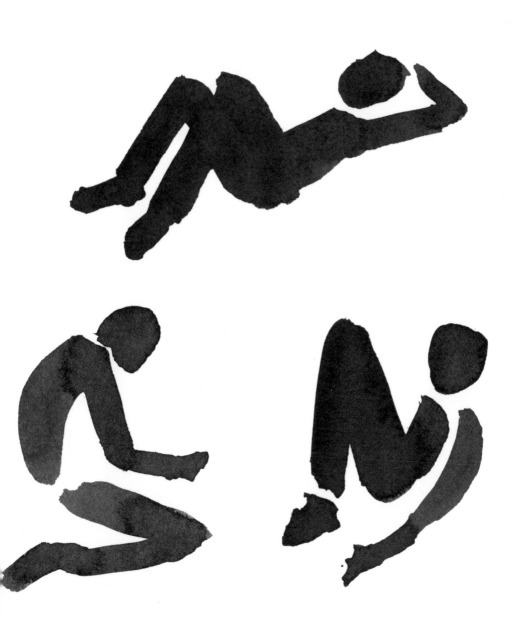

These figures depict slowness.

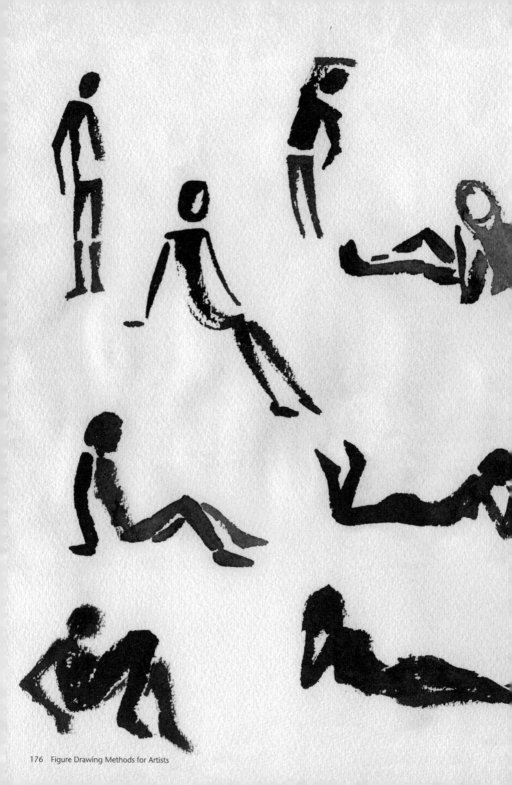

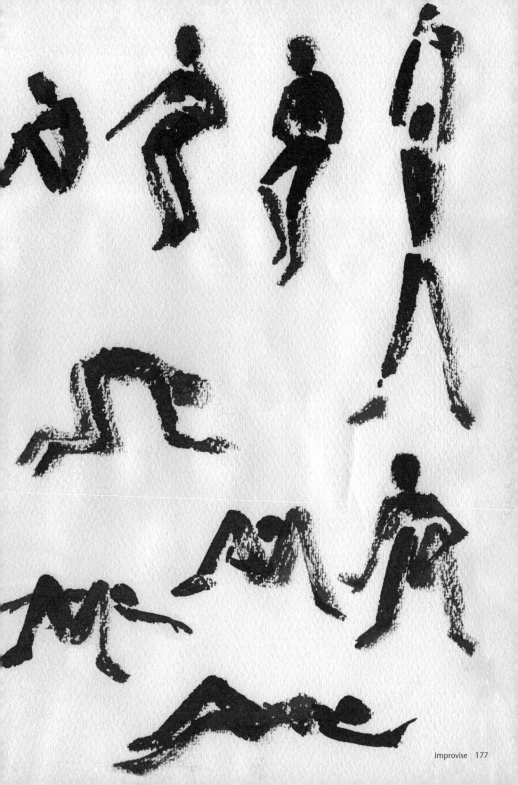

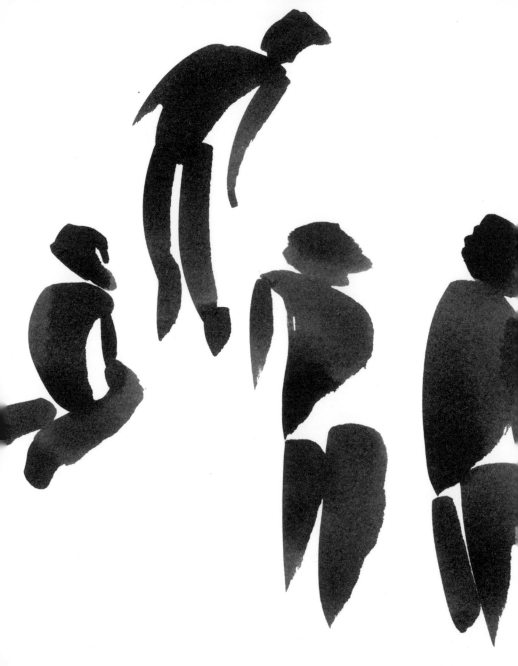

Depending on what happens during the first brush strokes,
the whole figure emerges. Improvising is
exciting, and the results can be surprising.

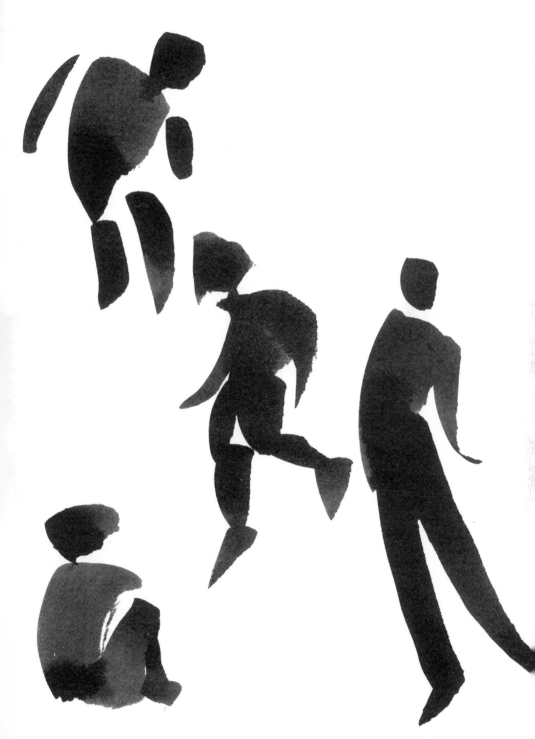

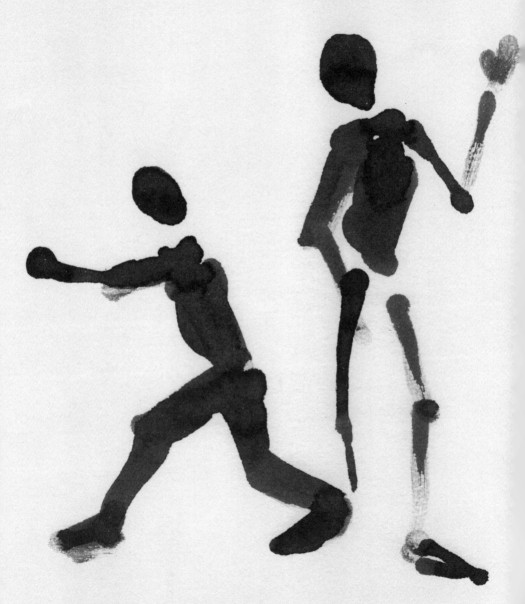

Dip your fingers in ink and start drawing—
your hand becomes your drawing tool.

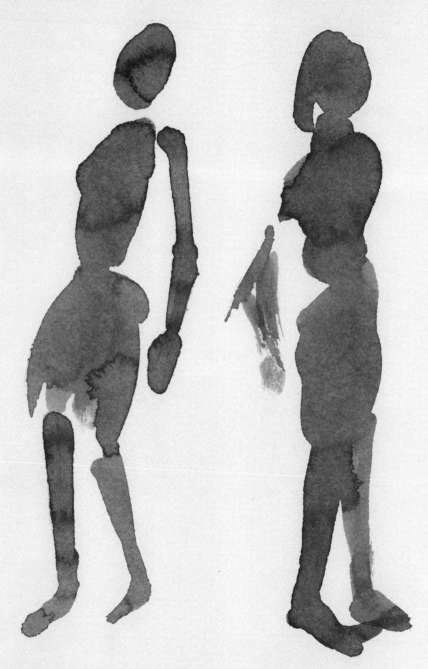

It's not the anatomical correctness, but
the immediacy of the actual doing that counts.

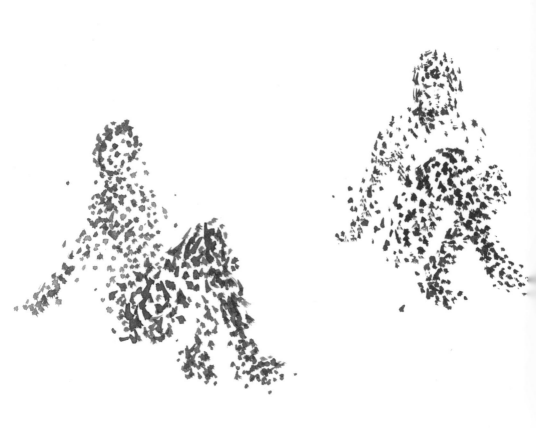

Place dots freely on a piece of paper and let the shape deve-
lop. This is much more exciting than determining
the outline beforehand and then painting it.

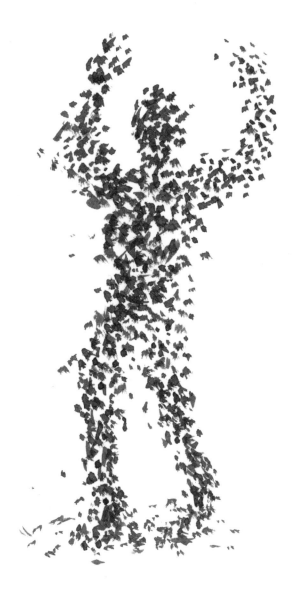

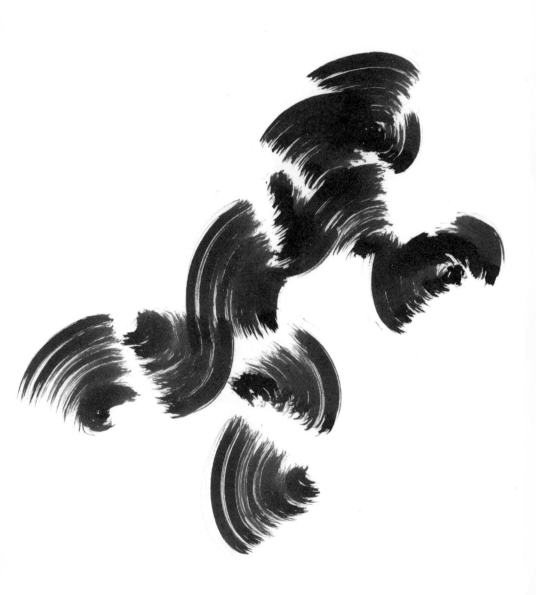

The brush circles, making the joints turn.

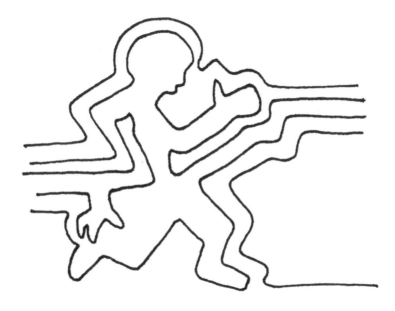

A rule turns improvisational drawing into a game in which the
lines lead from left to right and cannot cross each other.

Definitions

Anatomy

This is scientific knowledge about the human or animal figure. During the Renaissance, artists started cutting open dead bodies and drawing them, probably in hopes that this insight would help in their artistic practice to be able to depict more lifelike people. The anatomy drawings by Leonardo da Vinci were unsurpassed in realism and detail well into the twentieth century.

Anatomical Drawing

Today this type of drawing takes place more commonly in medical institutions instead of at art academies. An anatomical room exists at the Academy of Fine Arts in Vienna, but only one professor dissected corpses there at the end of the nineteenth century.

Caricature

This style was used in France for political commentary by Honoré Daumier (1808–1879). It is closely linked to the spreading of newspapers as an information medium. When a caricature targets a ruling person, it has to simultaneously show similarities and be exaggerated and pointed. The drawing can make a point naturally and without many words.

Contour

This type of drawing emphasizes the outer edge to clearly differentiate something from its environment. Outlined eyes, for example, seem bigger, more dominant, clearer, and sharper.

Contrapposto

This is the balance of calm and motion within a figure. Using this principle, the Greek classics developed an ideal, harmonious depiction of the human figure.

Facial Expressions

The many facial muscles allow for diverse expressions. It is questionable whether the abundance of human expressions can be reduced down to a few basic emotions and if a facial expression is universally open to interpretation and independent from heritage and socialization.

Figural

This is the artistic depiction of human, animal, or geometric shapes. The opposite of abstract painting, figural depictions use anything corporeal as an origin. The boundaries show fluid transitions; the conflict between both positions especially shaped paintings of the twentieth century.

Gesture

With hands, arms, and even the whole body, spoken words are visually painted. Common gestures, such as lifting the shoulders upward, say everything.

Ideal

This is a wide field influenced by philosophy, politics, advertisement, and fashion. In ancient Greece, people philosophized about the ideal body; originally, the word *idea* descends from ancient Greek. On one side, an ideal is subject to contemporary taste. On the other side, there are reliable factors for a universal sense of beauty. This is especially true regarding the body; for example, its symmetry and the golden ratio, such as the proportion of width to height in a face.

Likeness

This is the highest grade of resemblance without removal of the essential difference between origin and portrayal.

Mannequin

A wooden model of the human body with movable limbs, a mannequin can be helpful to create different postures and movements while drawing. But a mannequin is just a mannequin.

Mask

This is a facial coverup for religious or cultural rituals and for plays, such as African masks, carnival masks, protective masks, death masks, and so on. With this small piece of disguise, you become someone else quickly, which enables the wearer of a mask to do exceptional deeds.

Model

Often in architecture and design, a model serves as an example of something that doesn't yet exist, usually in the form of illustrated plans. In visual arts, a model is typically the inspiration for and origin of a piece of art. Many artists develop physical or emotional relationships with their models, which are reflected in the finished artwork. Examples include Pablo Picasso and Lucian Freud.

Nude

This is the depiction of the naked human body. During the drawing, the undressed model holds still for long periods of time so that there is enough time to draw a study of the figure. This exact observation teaches the basic

understanding of the body. Variations of this method include very quick drawings of posture, taking unusual perspectives, or experimenting with different mediums.

Outline
Quickly sketch outlines and don't get caught up in the details. The edge that separates the object or figure from the environment is of vital importance.

Portrait
This is the depiction of a whole figure, the face, or a half-length portrait. The resemblance of the portrayed person is obvious. People who wanted to obtain and preserve their faces past their own lifetimes depended on painting back in the old days. Today this task has been taken over by photography. The most famous portrait in art history is the Mona Lisa, whose resemblance to a real person is speculative. This painting was once considered a leading example of portraiture in art.

Pose
In comparison to natural movement or postures, the pose is rigid and usually reflects the artist's vision. Often poses are used when creating self-portraits. Posing in front of a camera means to take on a certain posture that can be quickly drawn.

Self-Portrait
For a depiction of one's own figure, self-questioning and presentation are important factors. It can be blunt, comical, vain, or sober. Reviewing the self-portraits of Max Beckmann, Rembrandt, and Goya can reveal something about how the artists viewed themselves. With masks and costumes, Cindy Sherman increases the self-portrayal into an obsessive deliberate confusion.

Silhouette/Paper Cut
This is a more or less simplified paper cut drawing. It usually is black or white and can also be used as a template for printing or spraying. As a silhouette, the facial features are more distinct than as in a profile.

Torso
This is only the trunk of the human body, with the limbs missing. For Rodin, the design of a torso was an artistic principle to emphasize the work process through supposed incompleteness.

About the Authors

Peter Boerboom and **Tim Proetel** both studied at the Academy of Fine Arts in Munich between 1991 and 1998 under renowned painter and teacher Horst Sauerbruch. Their long friendship has repeatedly led to joint work. This book is the latest result of their collaboration, which included many drawings and discussions. Three volumes about perspective, light, and motion are already published; more volumes on new themes are being planned.

Tim Proetel is an advisor for art at the state institution of school quality and educational research and teaches art and theater at an academic high school, both in Munich.

Peter Boerboom also studied communications design at the College for Design in Munich. He is a founding member of the artist group Department for Public Appearance and executes art and photography projects together with Carola Vogt.

Also Available

**Drawing Perspective
Methods for Artists**
978-1-63159-303-1

Figure Drawing for Artists
978-1-63159-065-8

**The Urban Sketching Handbook:
People and Motion**
978-1-59253-962-8